IMAGES
of America

MILLBURN
SHORT HILLS

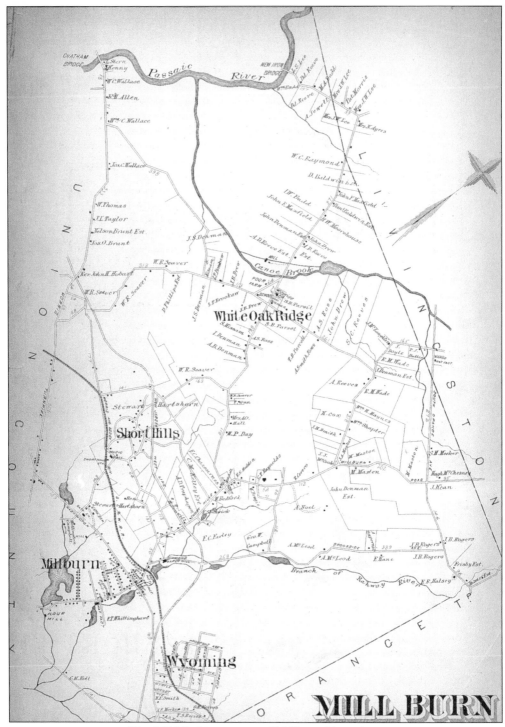

The 1890 Robinson map of Millburn Township.

IMAGES
of America

MILLBURN
SHORT HILLS

W. Owen Lampe
The Millburn-Short Hills Historical Society

ARCADIA

First published 1999.

Published by Arcadia Publishing,
an imprint of Tempus Publishing, Inc.
2 Cumberland Street
Charleston, SC 29401

Printed in Great Britain.

Library of Congress Catalog Card Number: 00-100181.

For all general information contact Arcadia Publishing at:
Telephone 843-853-2070
Fax 843-853-0044
E-Mail sales@arcadiapublishing.com

For customer service and orders:
Toll-Free 1-888-313-2665

Visit us on the internet at http://www.arcadiaimages.com

A group of townspeople were called together by Frances Evans Land in 1975 to establish an organization to further knowledge of the history, genealogy and architecture of the town. Thus, the Millburn-Short Hills Historical Society was formed. The society seeks to accumulate and preserve memorabilia, photographs, maps, and postcards and to encourage interest in local history by the dissemination of information about the town.

Society members have produced slide shows, booklets, walking tours, and a survey of homes which resulted in the designation of two historic districts. Extensive archives and mementos have been secured and the photograph and postcard collections are substantial. Additional material is continually being sought. Exhibits, research materials, and formal lectures are presented in the museum. The museum is housed in the westbound Short Hills railroad station building, which has been leased from Millburn Township since 1996.

THE COVER PHOTOGRAPH is of the Vaux Hall Inn during the 1907 semicentennial celebration of Millburn Township. The flag-draped inn served as a viewing stand for many local dignitaries.

CONTENTS

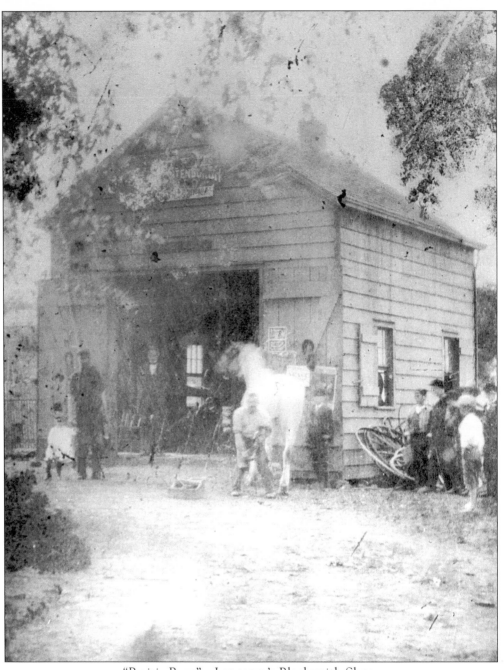

"Prairie Rose"—Lonergan's Blacksmith Shop.

INTRODUCTION

The history of Millburn Township traces back to the founding of Elizabethtown in 1664 and of Newark in 1666. Land purchased from the Lenape Indians by both settlements included portions of what is now our town. The first settlers arrived shortly after 1700 and several of their pre-Revolutionary homes still stand.

With the start of the Revolution, an active militia was formed and signal beacons were placed on South Mountain and above the short hills in Summit. On June 23, 1780, the right flank of British and Hessian troops attacking Springfield under General Knyphausen marched up Vaux Hall Road. They were met by the Continental troops who, with the determined aid of the militia, halted the invaders near the current town hall. The British forces merged at Springfield, destroyed the church and many homes, and retired to Elizabeth and thence Staten Island. It was their final invasion of New Jersey.

Following the Revolution, the area gradually changed from one of farms to one of grist, lumber, and paper mills. When the township of Springfield was separated from Elizabethtown in 1793, our community was a part of the new town and was referred to by such names as Rum Brook, Millville, Riverhead, and Vauxhall.

A major factor that influenced the growth and development of the area was the opening of the Morris and Essex Railroad on October 2, 1837. It greatly benefited local industries and provided transportation for summer residents retreating from the heat and dirt of the cities. The township of Millburn was created by the state legislature on March 20, 1857. Union County was carved from the southern portion of Essex County on that date. The township of Springfield was split between the two counties with the northern portion becoming Millburn Township.

The presence of the railroad continued to play an important role in the development of the town. The Wyoming Land Development purchased 100 acres from the Meeker, Hand, and Reeve families to build a suburban railroad community in 1874. Two years later, Stewart Hartshorn began the purchase of land for his envisioned "ideal community" which he named "Short Hills." With the development of these two areas, Millburn began to evolve into the premier suburban community that it is today.

By the turn of the 20th century, Brantwood and Glenwood were being developed and South Mountain Estates, the Whitney Road section, Nottingham, and the Day Estates were soon to follow. Roads, homes, and schools began to cover the western slopes of Short Hills following WW II until today when few undeveloped lots remain in the township.

The pictures dating from the 1870s to the 1980s and the descriptions in this book provide a view of Millburn's past. They are presented by areas of town so that walking or driving tours are possible. Enjoy what you recognize or remember and learn about those things that are new to you.

ACKNOWLEDGMENTS

John Donne (1572–1631) once said, "No man is an island, entire of itself." These words ring true when creating a captioned picture book of a town.

An enormous debt is owed to the Millburn centennial committee and to those who wrote and assembled the book, *Millburn 1857–1957*. Marian K. Meisner researched local history for the book and prepared a more detailed history, which can be found at the Millburn Free Public Library. As many as 450 old photographs were gathered at the time. These materials serve as a basis for the present volume along with information from the historical society archives, from local church and organization histories, and from histories of Essex County and surrounding communities.

Many photographs in the collection of the Millburn-Short Hills Historical Society, some appearing in this book, have been made possible by Ira Schwartz who for the past 25 years has given unstintingly of his time to the copying, developing, and printing of loaned materials. He has employed archival methods for preservation purposes and has frequently enlarged prints for presentation.

Countless numbers of townspeople have given or loaned their personal albums and photographs for viewing in the public domain. Their generosity and interest is greatly appreciated by all who are vitally interested in the collection and preservation of local history. Residents and former residents continue to add to the collections and to relate details of life in bygone days.

Abundant thanks are due to the following individuals who have played a vital role in the preparation of this book: to Michelle Miller for envisioning and pursuing completion of the project; to David Siegfried for negotiating the contract; to Brian Kobberger for implementation of the cover design and the 1764 Ball map; to Maureen Kundtz for picture selection from hundreds in the collection; and to Lynne Ranieri and Ann Talcott for editing. Thanks are also due to my wife, Hope, for editing and re-editing and for living with boxes of photographs and memorabilia for much of our married life; and to the officers and trustees of the Millburn-Short Hills Historical Society who have waited hopefully and patiently for the appearance of this volume.

One

MILLBURN:

FOUR CORNERS AND VICINITY

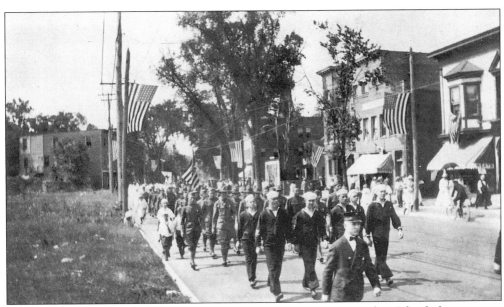

Main Street and Millburn Avenue have been the route of many parades. After helping to win World War I, sailors and soldiers march up Main Street in a celebratory parade.

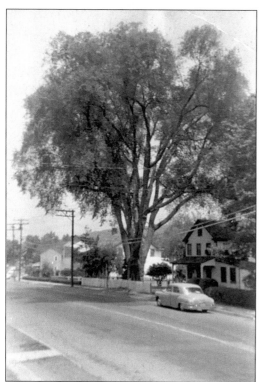

This gigantic elm tree stood in front of 298 Main Street long before the first settlers arrived. It died in 1968 from the elm blight. About 1927, the owner extracted a four-pound cannon ball from the tree, undoubtedly shot there during the June 23, 1780, Battle of Springfield. The tree was pictured in *Life* magazine in 1946.

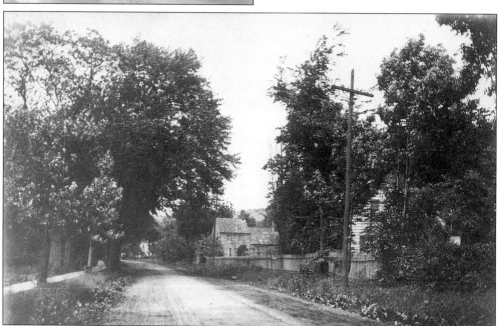

In 1900, Main Street at Meeker Place was still a country lane. The first church in the area, a log structure, was built at this location in 1740, and served the community of Springfield until 1761, when a new church was constructed on Morris Avenue. A glebe of 200 acres was granted to the church and minister on today's Parsonage Hill Road, hence the name for the street. The glebe was finally extinguished in 1863.

The last operating mill in town was the Fandango Mill, which closed about 1960. This aerial view shows the plant layout and millpond. The buildings were demolished and the Lakeside Apartments built on the site at 206-210 Main Street.

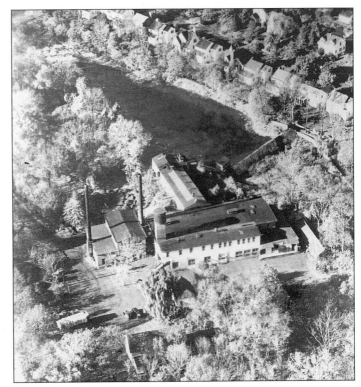

Casa Columbo, a non-denominational social, fraternal, and charitable organization, is located at 189 Main Street. It was organized in 1924 and 14 years later purchased the Robert Marshall home shown here. In recent years, the building has been altered.

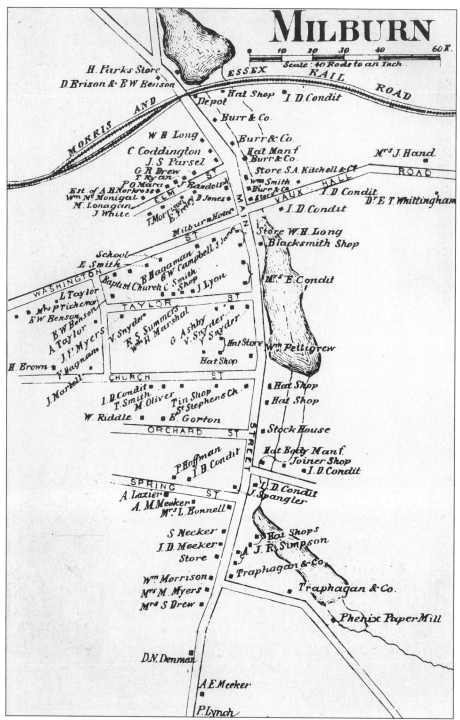

An 1859 map of Millburn center shows how developed the Main Street area was two years after the town was incorporated. Total population was under 700. Many of the family names dated back to the early settlers. Paper mills and hat mills were the main industries, and hat shops were the main retailers.

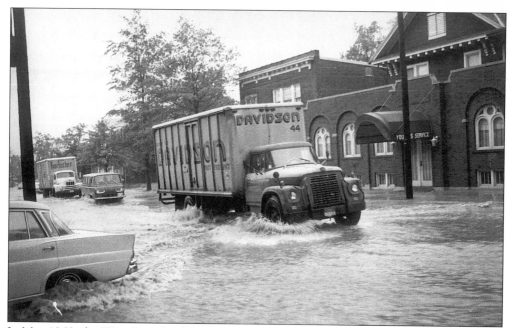

In May 1968, the West Branch of the Rahway River flooded. It turned Main Street into a river and basements of many homes in the area were inundated. The truck is heading north, and Young's Funeral Home is at the right on the corner of Rector Street. Apartments occupy the site today.

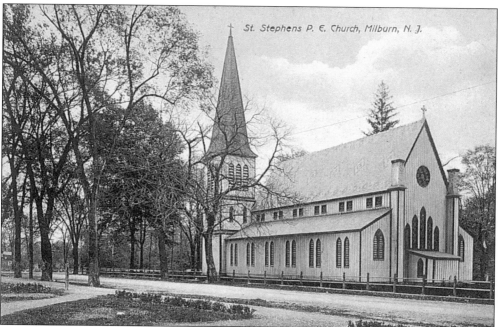

St. Stephen's Church (Episcopal) was formally consecrated on July 24, 1855. Designed by J. W. Priest in the American Gothic style, the building was begun in 1853 on land donated by Israel D. Condit. The church seats 300 and is little altered except for the organ, which now blocks the five rear windows.

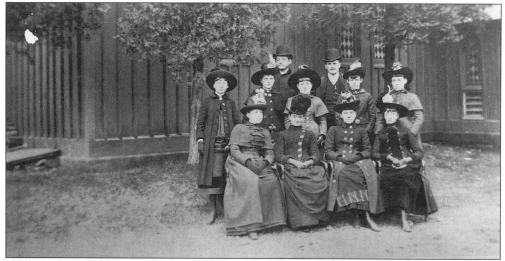

Parishioners of St. Stephen's pose in their Sunday best. Miss Amelia Parks is seated second from the left. She served as the church organist from 1869 until 1925 and as a Sunday school teacher for almost 70 years.

The African Methodist Church is located at 54 Church Street. The congregation formed about 1881 when a few worshippers met with a minister. The church building was constructed in 1902. The exterior has been altered since this picture was taken in 1956.

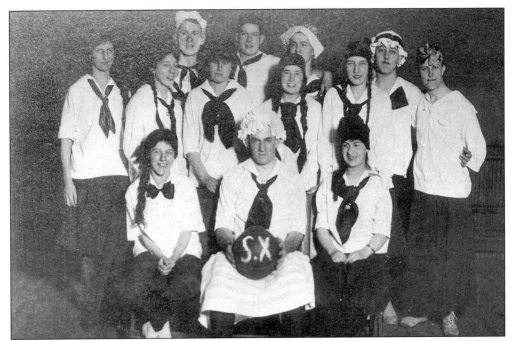

A number of local basketball teams used the St. Stephen's parish house for practice and for their home games. In 1899 a girls' basketball team was formed called the S.X. Essex Club. Between 1901 and 1904, men were also members. Girls' rules were used and it looks like the men used girls' outfits too!

Mr. and Mrs. John Taylor gave the former Isaiah Smith home at 12 Taylor Street to the Neighborhood Association in 1918. This organization, originally started in 1894 by Mrs. Stewart Hartshorn, maintains a nursery school and provides visiting nurse service to the community.

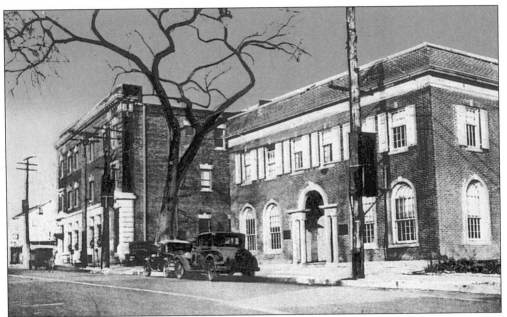

The U.S. Post Office was located at 62 Main Street before the current building was opened in 1938. The First National Bank of Millburn, in the rear, was completed in 1909.

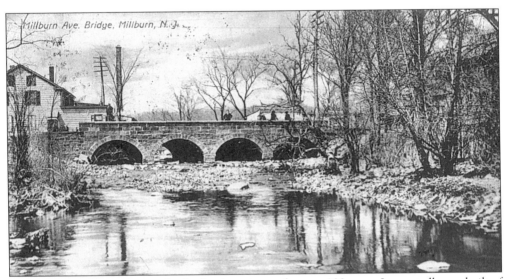

Millburn Ave. Bridge, Millburn, N. J.

The current Millburn Avenue bridge has been in use for over 100 years. It reputedly was built of stone from the previous bridge on the site.

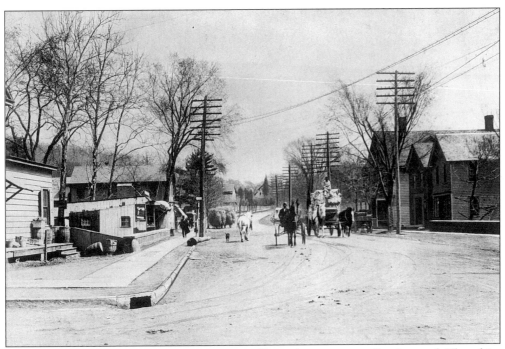

Looking east from Main Street before 1900, Millburn Avenue was still a dirt road. The white horse with dog companion is on its way to the blacksmith's to be reshod. The horse-drawn wagon is loaded with scrap paper and rags for one of the paper mills. The two peaked buildings are still extant.

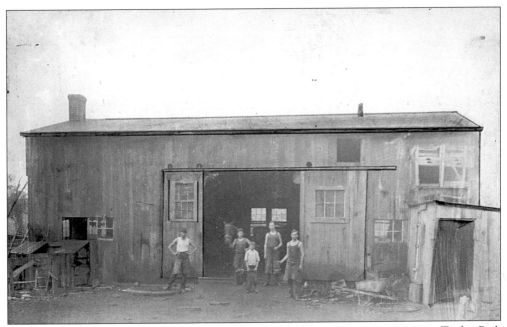

Tichenor's Blacksmith Shop was located where the Millburn Avenue entrance to Taylor Park is today. The Tichenor family was still in the iron business until a few years ago.

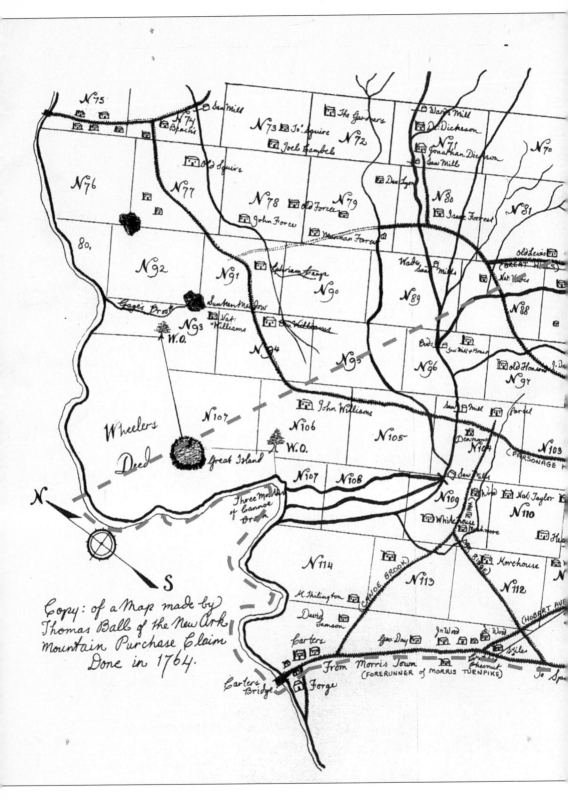

Copy: of a Map made by
Thomas Ball of the New Ark
Mountain Purchase Claim
Done in 1764.

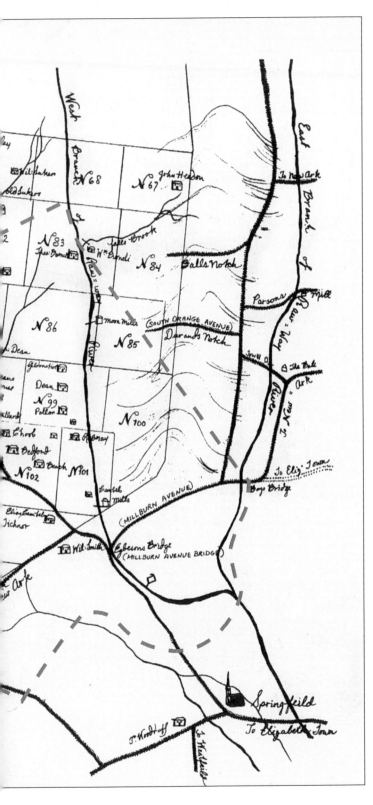

Newark was settled in 1666 on land purchased from the Lenape Indians. The purchase went to the foot of the Watchung Mountains. Later the lands were extended to the Passaic River by the New Ark Mountain Purchase. A final purchase, the Horseneck, covered the present day communities in northwest Essex County. This is the Ball map done in 1764 for the New Ark Mountain Purchase Claim. Chains were used to make the measurements. The approximate present day borders of Millburn Township are shown by the dotted line. A list of the early landholders follows. The number identifies the tract as shown on the map.

BEACH'S	74	EGBESONS BRIDGE	101*	POLLOR	99
JNO. BARNELLI	83	JOHN FORCE	78	PARCIL	104
WM. BARNELLI	83	OLD FORCE	78	REBURAY	101
BUD'S SAWMILL &		MINNAN FORREST	79	SAWMILL	71-74-104
HOUSE	96	ISAAC FORREST	80	JO. SQUIRE	73
BILLARD	98	FORGE	114*	ELI SQUIMS	74
BEDFORD	102	FULLIGS GRIST MILL	‡	OLD SQUIMS	77
BEACH	102	THOS. GARDNER	72	M. SHILINGTON	114
SAM BEACH	102	COR. GARDIN	73	DAVID SA . . . EN	§
BOND	109	GILDERSLIVE	99	STILES	112*
JOEL CAMBELL	73	WIL. GREEN	101	WT. SMITH	111*
EPHRAIM CAMP	91	BEN GREEN	101	TOWNLEY	69
CAMBELL	101	JOHN HEADON	67	NAT TAYLOR	110
CHOATE	102	OLD HONSARS	97	EZ. TAYLOR	110
ELIAS CAMBELL	111	HEADLEY	110	JO. TICHNOR	111
CARTERS BRIDGE	114*	LINDLEY	60	WIL TAYLOR	101
DR. DICKESON	71	WILL LUKERS	69	WARDS MILL	71
JONATHAN DICKESON	71	OLD LUKERS	69	NAT WADES	88
DAN DEAN	87	DAN LYON	73	WADES SAWMILL	89
J. DEAN	98	OLD LEWIS	81	NAT WILLIAMS	93
DEAN'S NEW HOUSE	98	JOHN LUKERS	82	BEN WILLIAMS	94
DEAN	99	MOONS MILL	85	JOHN WILLIAMS	106
DENMAN	104	MILL	101	WHITEHEAD	109
GEO. DAY	114*	TIM MEAKER	102	JN. WOOD	113*
ROB EARLE	82	MUSHMORE	109	IS. WOOD	112*
OLD EARLES	87	MOREHOUSE	112	J. WOODRUFF	¶

*The asterisk indicates properties near the tracts indicated.
‡On the stream between Egbeson's Bridge and Springfield.
§Name illegible.
¶In Springfield at the Westfield Road.

NOTE: "Round Meadow" and "Sunken Meadow" on tracts 92 and 93 are roughly somewhere northwest of the East Orange Golf Club grounds. Egbeson's Bridge corresponds to the Millburn Avenue Bridge. The road that runs roughly from tract 102, through 103, 104, 105, 106, 94, 91, 77 obviously parallels the Parsonage Hill Road. The highway that begins on the Morristown Road (Morris Turnpike) at the "Crotched Chestnut" and skirts the lower edge of the tracts is practically Hobart Avenue, until it crosses the present site of Taylor Road, and follows the D.L.&W. right of way to Old Short Hills Road. The inverted "Y" in the lower part of the map would be White Oak Ridge Road, and its present fork, Canoe Brook Road. The three ribbons of water converging in tract 109 are indicated as the "three mouths of Cannou Brook" where they enter the Passaic River, in tract 107. On the right hand (southeast) edge of the map, where the mountains are shown, there appears Durand Notch, entering tract 85, which is apparently the forerunner of South Orange Avenue. Above that is Ballo Notch. Note that the stream which flows down through tracts 59, 68, 83, 86, 99 and 101 is called the Raw Way River. Tract No. 101 has an additional acreage below 111.

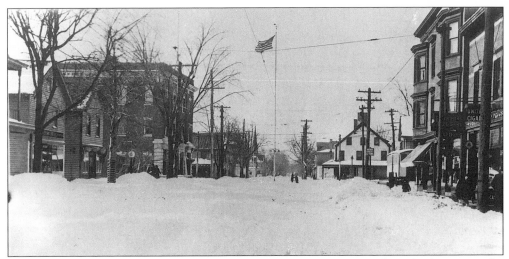

Looking west on Millburn Avenue across Main Street in 1920, a flagpole dominates the intersection, the old stagecoach stop and hotel is still on the northwest corner, and a diner is on the right over the river. The heavy snow has stopped all traffic including the trolleys that run on two tracks between Springfield and the Maplewood loop. A few years later the flagpole was moved to Taylor Park.

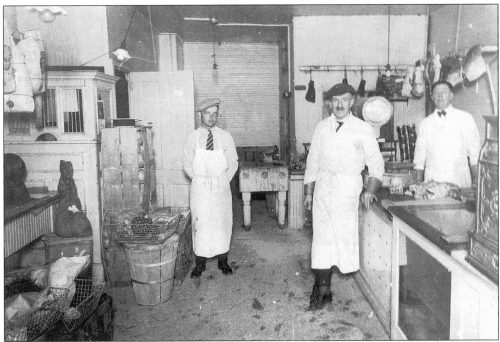

Before supermarkets came to town around 1940, small grocery stores and butcher shops could be found throughout the town. On May 20, 1925, Lonergan's meat shop was photographed. It was located in the building that is now 330 Millburn Avenue.

Israel Condit could be considered the father of Millburn. His efforts brought the Morris and Essex Railroad through this area. When Union County was splitting from Essex County, his negotiations kept the northern portion of Springfield in Essex to become Millburn Township. His home stood at 321 Millburn Avenue and later became the Vaux Hall Inn.

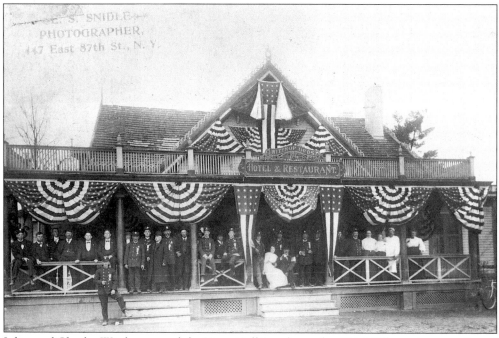

Julius and Charles Wittkop owned the Vaux Hall Inn, located at 321 Millburn Avenue. One of the popular gathering places in town, the Essex County Freeholders often met here. For the 1907 semicentennial celebration, it served as a viewing stand for many dignitaries. The Art Deco building that now occupies the site was built circa 1930.

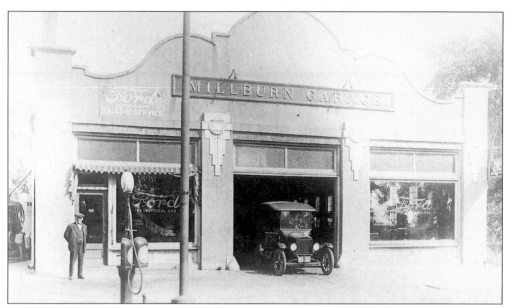

Julius Wittkop owned the first automobile agency in town. Note that the Ford dealer ran a repair shop and pumped gasoline. The agency was located just to the east of the Vaux Hall Inn on Millburn Avenue.

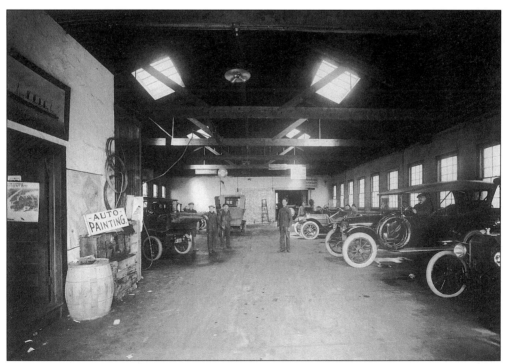

The interior of the Ford dealership repair shop shows a touring car and roadster on the right. The picture may be as early as 1911 or 1912. Since 1940, the building has held several stores including a supermarket, a dress shop, and a carpet store.

The center of Millburn has been hit with numerous floods over the years. Two cars can be seen negotiating the floodwaters in front of the Atlantic & Pacific Grocery store at 333 Millburn Avenue in 1927.

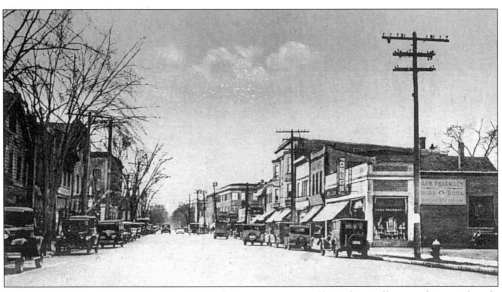

A view of Millburn Avenue circa 1928 shows two-way traffic. The trolley tracks are already gone. Back on the corner of Main Street, the old hotel has been replaced by a three-story brick building. The hotel was actually moved down the block on Millburn Avenue across from the theater and bricked over to match the new building. Today both buildings are named The Courtyard.

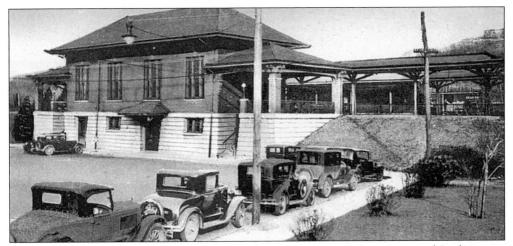

The Millburn railroad station was moved from Main Street to Essex Street and Lackawanna Place during the last major reconstruction of the line between 1907 and 1912. The imposing brick building was recently replaced by an office building. A duplicate of the old station can still be seen in Boonton.

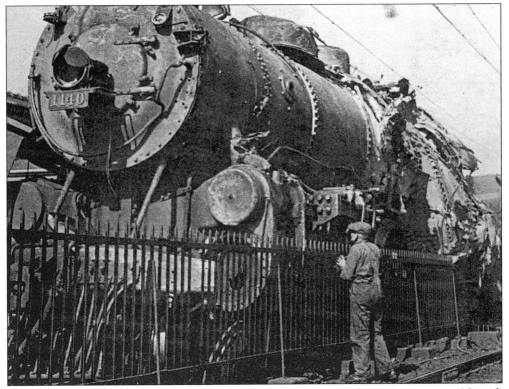

On Sunday August 18, 1941, the regular three-milk-car train run from Morristown to Newark left the tracks on the curve before the Millburn station tearing up the tracks and ending up at the station. The engine was on its side, the milk cars crushed, and the coaches damaged. A fireman was killed. For several days, the town was filled with sightseers. Commuters from the west had to be bused around the accident. Here, the engine has been righted but the damage is evident. .

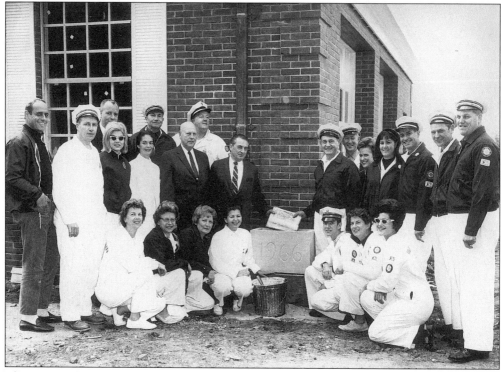

The First Aid Squad building was dedicated in December, 1966. A crew room was added in 1975 and in 1985, the bay was changed from two single garages facing the side of the building to one with front and back entries. The squad was organized in 1958.

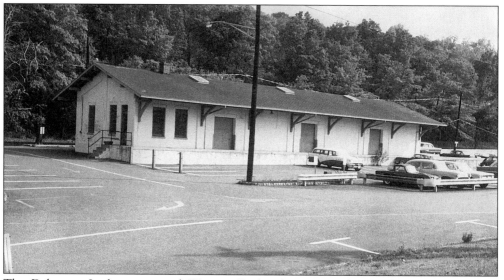

The Delaware, Lackawanna, and Western Railroad maintained a freight station on Glen Avenue at the Millburn railroad station until after World War II. In 1957, the township bought the property and turned the yard into a commuter parking lot. The First Aid Squad building is now located on the site.

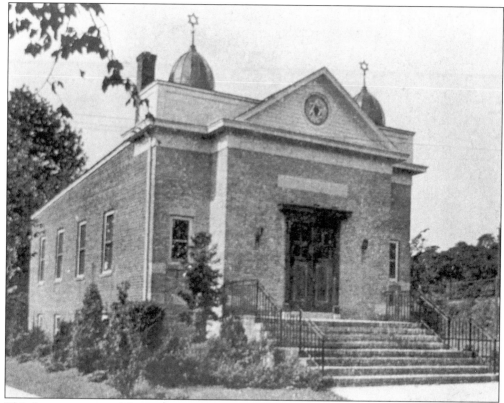

This first synagogue of Congregation B'nai Israel was on Lackawanna Place and was completed in 1925. First worship services trace back to the early 1900s when members met in homes or stores and later in the St. Stephen's parish house. In 1951, the congregation moved to their new building at 162 Millburn Avenue, which has been called "an outstanding example of modern religious architecture."

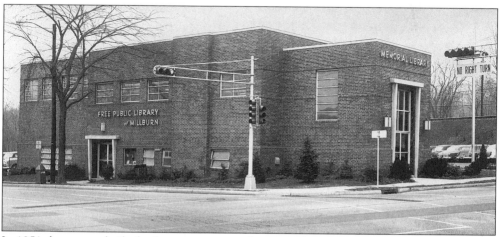

In 1951 the town rebuilt the former synagogue for use as the second home of the Millburn Free Public Library. This served as the library until 1977 when the present building was dedicated. The site is now part of a municipal parking lot.

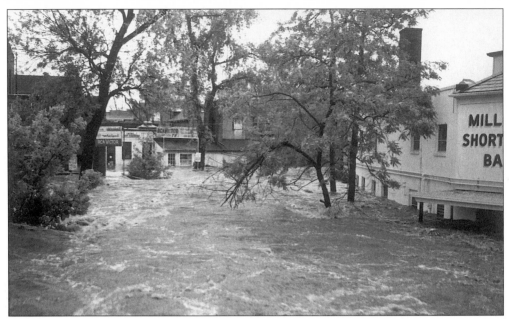

The floodwaters in 1968 overflowed the banks of the west branch of the Rahway River south of Essex Street. The basement of the bank building on the right was completely flooded and the stores along Millburn Avenue, seen in the background, were inundated with the water that carried all kinds of merchandise into the street.

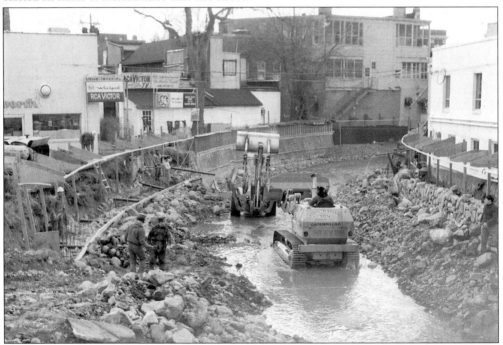

The town's solution was to channel the west branch of the Rahway River between stone walls that were as high as the river passageway under the bridge on Essex Street. The construction in progress shown here was completed before another flood occurred a few years later. The walls mostly contained the water flow and damage was limited.

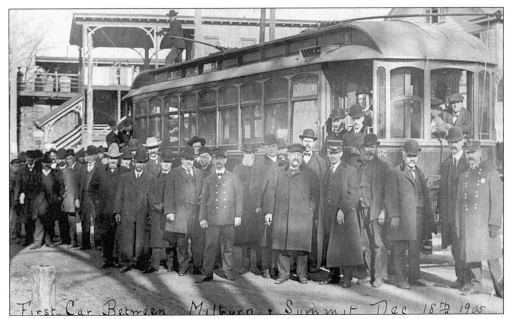

First Car Between Millburn & Summit Dec 18th 1905.

Dignitaries pose before the first official trolley car that arrived in Millburn center from Summit on December 18, 1905. At first a single track ran from Millburn railroad station on Main Street to Summit, but a 1907 town ordinance allowed the Morris County Traction Company to extend the line to the Maplewood loop. A second track was added, probably when the line was extended.

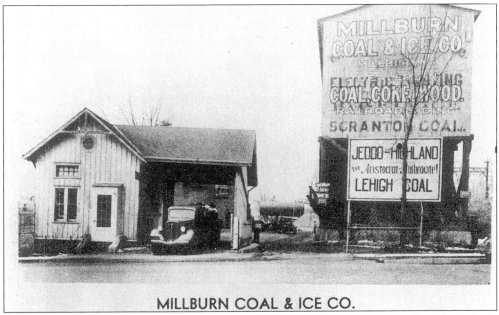

MILLBURN COAL & ICE CO.

The Millburn Coal and Ice Company stood to the west of Main Street just south of the D. L. & W. Railroad. Coal was received by hopper cars that were pushed up into the shed by the steam engines. Dumped by grade or type into large individual chutes, coal was loaded into dump trucks from above. The coal shed stood until recent times and was demolished when the town purchased the property for use by the public works department.

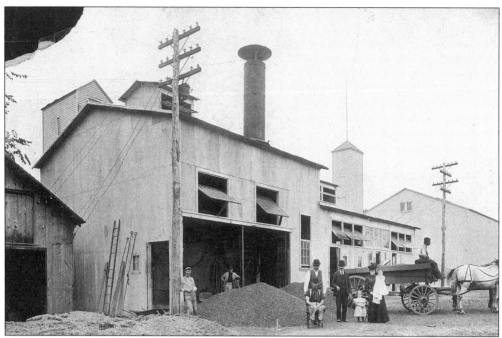

William Rollinson Whittingham organized the Millburn Electric Company in 1895. The plant was first sited on Mechanic Street but was later moved nearer to the railroad and the coal company. The company was sold to Jersey Central Power & Light Company in 1925.

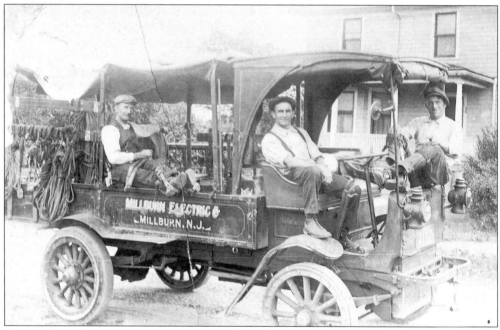

Walter Wyckoff is at the wheel of the Millburn Electric Truck with Louis Tompkins on the hood and Sam Woodruff in the rear. The truck was run on batteries. The license plate indicates that the picture dates from 1920.

The Felix Cardone Café was located on Main Street south of Essex Street. In later years, while still owned by the Cardone family, the name was changed to Mario's.

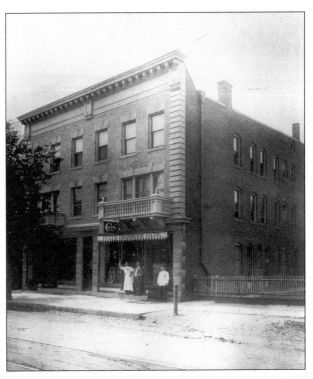

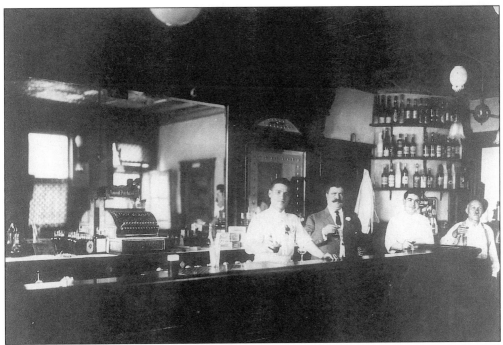

The Felix Cardone Café held one of the liquor licenses in town. After it became Mario's, an addition was constructed that extended the building to the corner of Essex and Main Streets. The bar was relocated and the dining area enlarged. Now part of a restaurant chain, it is still a popular local gathering place.

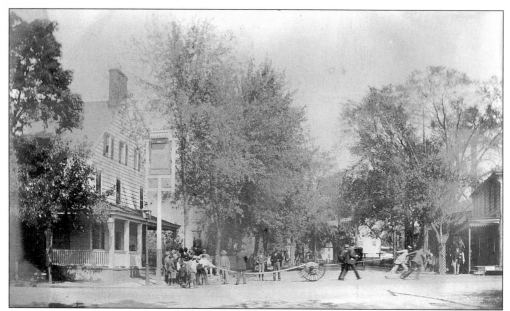

Shortly after 1900, the Millburn Fire Department secured a new hose reel. The first drill was held on Main Street in front of the old stagecoach stop, later the David Jones House, the Eagle House, Millburn Hotel, and Smith's Hotel. Mundy's Livery was across the street. The hose reel is still in the possession of the fire department.

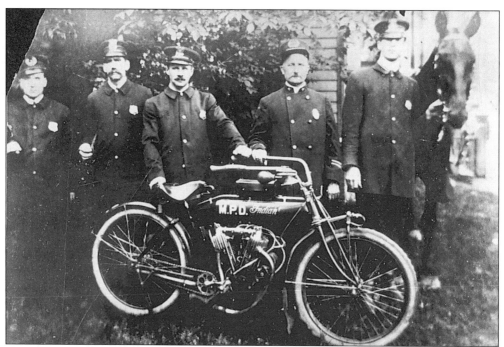

Although there had been a "Millburn Mutual Protective Society" as early as 1868, the Millburn Police Department was not organized until 1907. When the first motorcycle was purchased about 1911, the department posed for this picture showing the foot patrolmen, the motorcyclist, and the horse rider. Chief John Storey is second from the right.

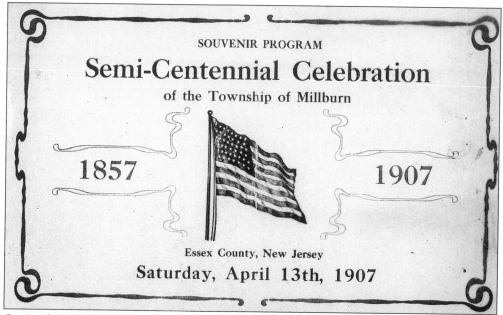

SOUVENIR PROGRAM

Semi-Centennial Celebration
of the Township of Millburn

1857 1907

Essex County, New Jersey
Saturday, April 13th, 1907

On April 13, 1907, Millburn held a semicentennial celebration to commemorate the separation from Springfield on March 20, 1857. Buildings in town were draped with flags, an elaborate parade was organized, and the festivities ended with much food and drink.

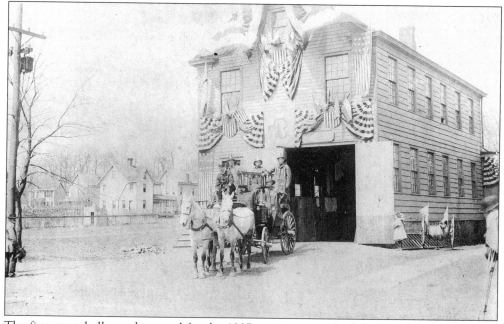

The first town hall was decorated for the 1907 semicentennial celebration. The building had been the old Washington School, which was moved across Millburn Avenue to become the town hall when the new school was opened in 1895. Offices were upstairs and the fire equipment was garaged on the first floor.

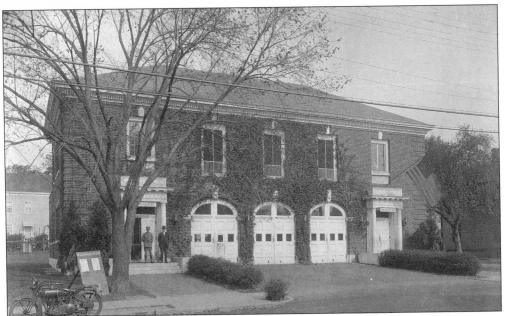

In 1912, a new town hall was built on the site at 375 Millburn Avenue. The police department was on the left and the fire department on the right with fire equipment behind the three doors in the center. The large room above the garage was the sleeping quarters for the firemen; it is now the Millburn Township Committee meeting room.

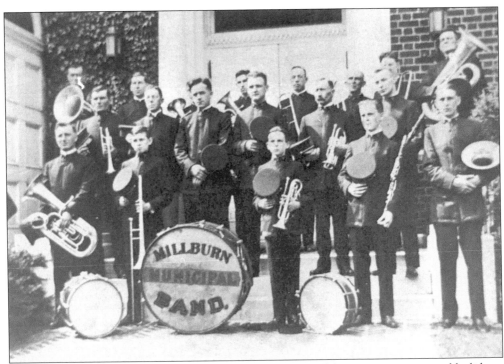

After 1910, the Millburn band was a popular attraction at celebrations, concerts, and holidays.

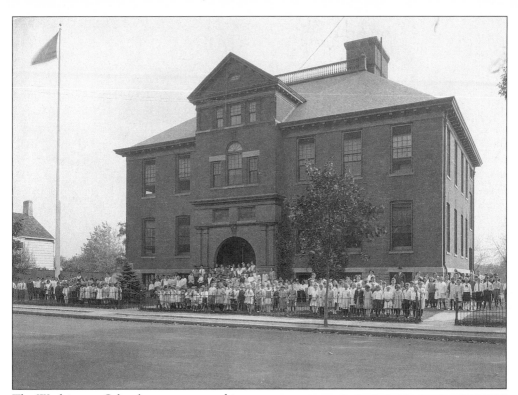

The Washington School was constructed in 1895. When it opened, several wooden schools in town were closed and most public elementary school education was consolidated. Although undated, this is an early picture because no additions have been made to the building. It is obvious that near the start of the 20th century there was a sizable school population.

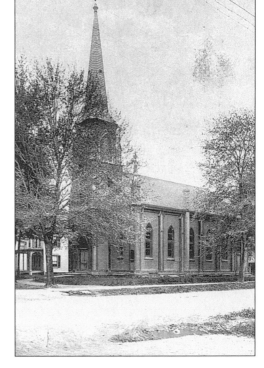

The cornerstone of the First Baptist Church, located at the southwest corner of Millburn Avenue and Spring Street, was laid on August 10, 1859. The founder of the church was Mrs. Isabella Lee who was 72 years old at the time. She donated the land and $1,000 toward the building's construction.

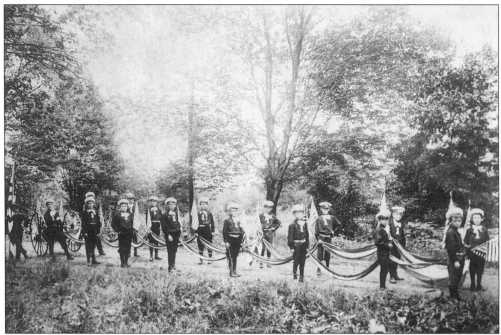

The firemen's sons are lined up for the 1907 parade. They each carry an American flag and, by use of the ribbon, they will pull the hose reel to the plaudits of the cheering crowd.

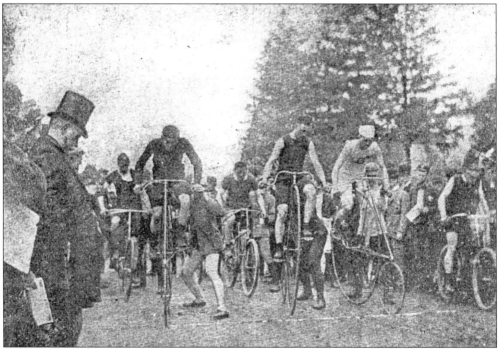

The leading bicycle race in the country, begun in 1889, was the Camptown Race that took place on Memorial Day each year. The race started at Prospect Street in Maplewood, went to Irvington center (then know as Camptown) and turned back to Millburn with repeats of the route totaling 25 miles. Famous riders from around the country regularly competed.

Two

WYOMING

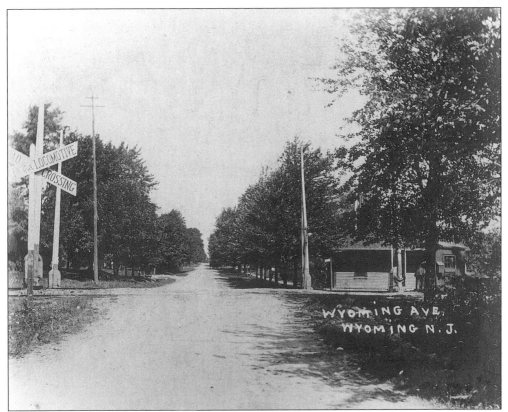

In 1894, 19 trains in each direction were stopping at the Wyoming station. By 1900 when this photo was taken, gates were in place both for the safety of the public and to reduce delay of trains.

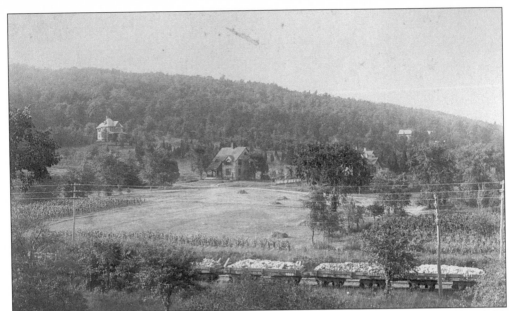

This view of Wyoming up South Mountain was taken in 1888. Of interest is the fallow field, the rock-loaded cars on the railroad, and the flat-to-sloping land. The two houses visible are in Queen Anne style. On the left is 213 Sagamore Road (c. 1882). In the center is 234 Sagamore Road (c. 1888) designed by Joy Wheeler Dow, a town resident and noted architect of the day.

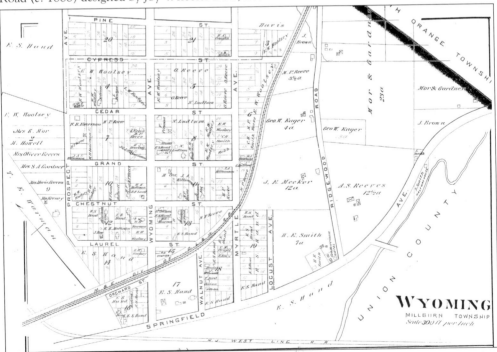

The 1890 map of Wyoming shows the checkerboard layout of the streets. It was in 1872 that the Wyoming Land Development Company purchased 100 acres from the Reeve, Meeker, and Hand families and began to build homes. Most likely, the community is named for Wyoming Valley, Pennsylvania, the home of the Lackawanna Railroad.

38

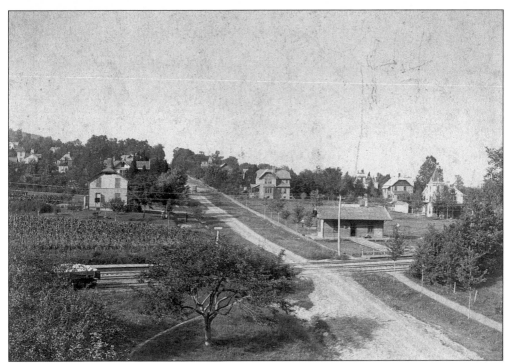

This view is of Wyoming Avenue in 1888. To the right is an Italianate-style house with a tower topped by a pyramidal roof. In the center is 454 Wyoming Avenue (c. 1872) and on the left is 461 Wyoming Avenue (c. 1881). Note the tree-lined streets, the cornfield, and the three tracks of the railroad.

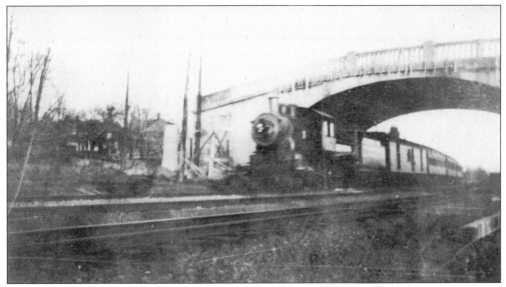

In November 1916, the Wyoming Avenue bridge across the tracks of the Lackawanna Railroad was still under construction. It eliminated the frequent gate closings due to the heavy commuter traffic on the railroad. Notice that a camelback engine is still in use.

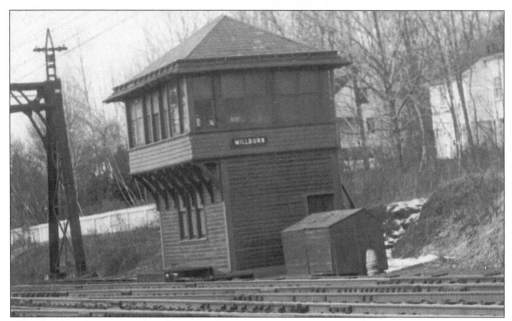

The switching tower stood to the west of Wyoming Avenue. It was a favorite spot for youngsters to visit when returning home from the high school on Old Short Hills Road. The tower controlled the switches located near it, which allowed trains to transfer between the three tracks as well as those switches just west of the Millburn station where the line is reduced to two tracks.

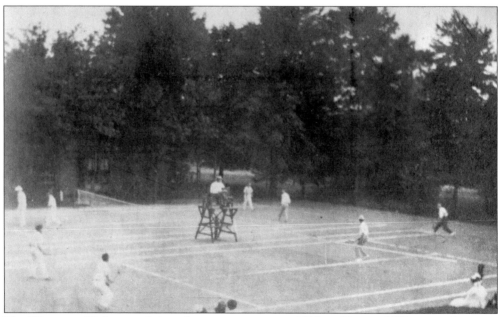

The Wyoming Club opened their first tennis courts in 1899 at Glen and Wyoming Avenues. The club is now located on Linden Street.

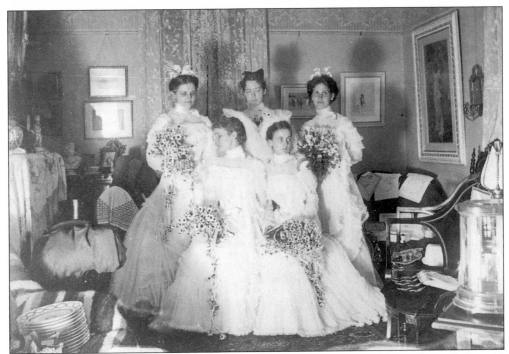

Here is the bridal party of Mrs. Herbert Marshall Sr. The Marshall family resided at 49 Chestnut Street for over one hundred years.

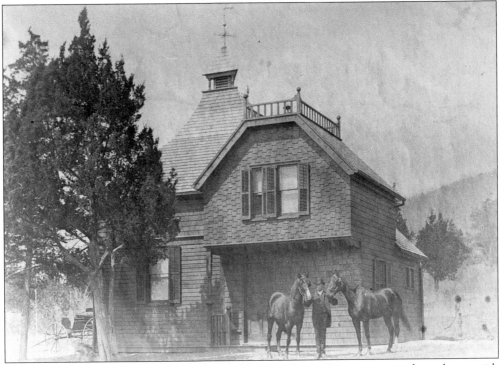

This building was the carriage house for 49 Chestnut Street. It was converted to a home with the address of 51 Chestnut Street.

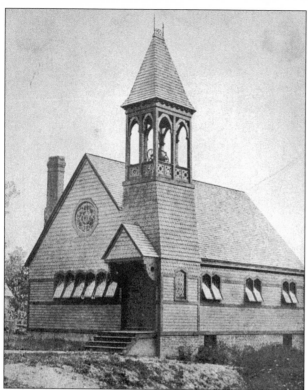

This wooden building was the original home of the First Presbyterian Church of Wyoming, N.J. It was first occupied in December 1883 and served the congregation until 1932 when it was replaced with the present brick Colonial style structure. The first services of the church had been held in the little railroad station on Laurel Street on November 9, 1873. No trains ran on the Sabbath so services were not interrupted.

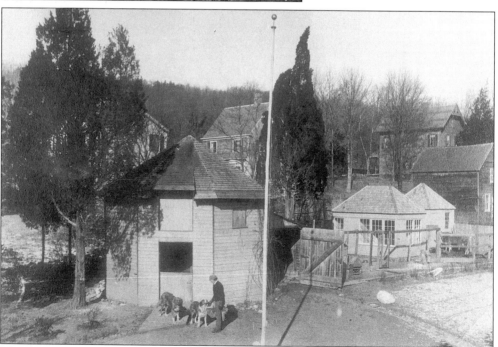

This hexagonal barn stood to the rear of Wyoming Church. With additions, it was made into a private home and is today owned by the church. Homes on Wyoming Avenue are visible in the background.

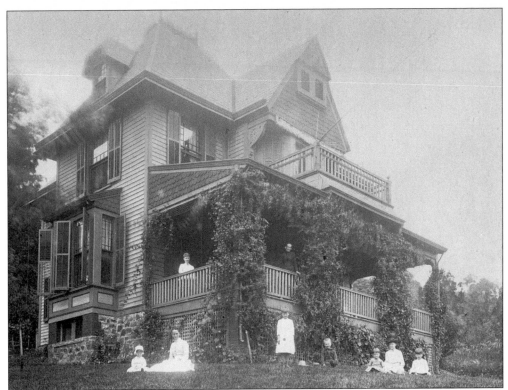

A popular photo in the late 1800s was of the family in front of the homestead. About 1893, the ladies and children of the Keeney family posed for this portrait in front of 213 Sagamore Road. The house is in a Queen Anne style and was built about 1882.

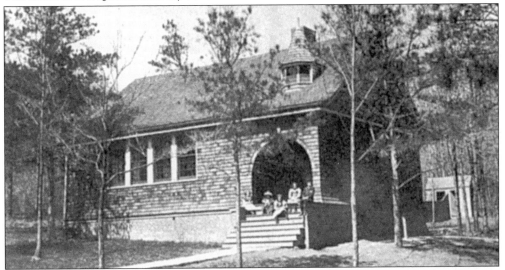

There are indications that a few school classes were first held in the Wyoming railroad station. The first school building, however, was located at what is now 119 Cypress Street. It was opened during the 1894–95 school year. The shingle style building was later converted into a private residence and from 1942 until his death was the home of world-renowned cellist, Maurice Eisenberg.

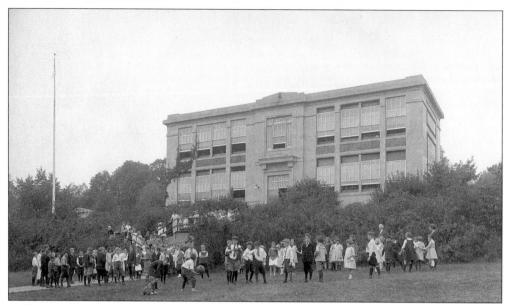

In September 1910, a new fire-resistant school building was opened on Myrtle Avenue between Pine and Cypress Streets. The building was 75 feet long, 45 feet deep, and cost $23,500. There were four classrooms, an office, a library, and a teachers' room. A unique feature was that, by raising partitions, a large assembly room could be created.

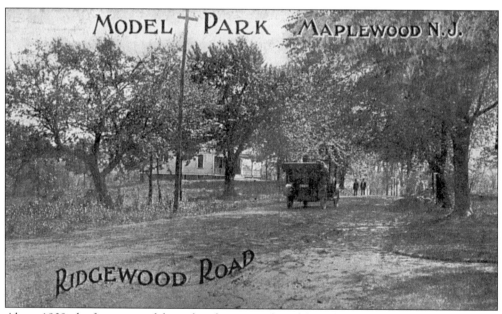

About 1909, the farms east of the railroad were purchased for a development called Model Park. The postcard photograph is taken on Ridgewood Road and the house is the Eagner's, today at the corner of Norwood Terrace. Until 1958, Wyoming received mail through the Maplewood post office, which explains the incorrect designation on this post card.

Of interest is this monthly bill for meat from Geo. W. Eagner dated April 23, 1889. Imagine paying 23 cents for "stake" while three times as much beef cost 54 cents.

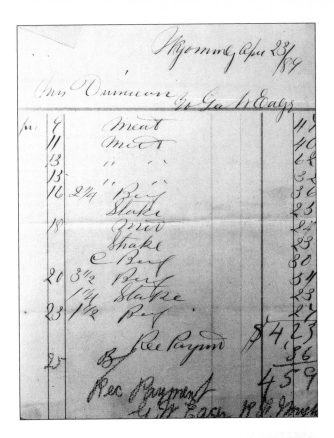

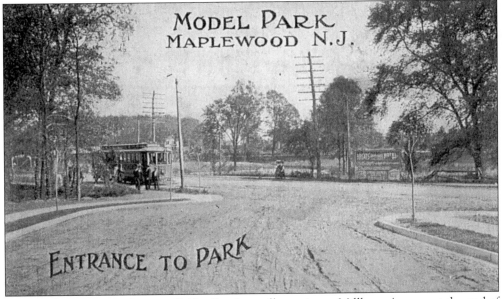

Looking down Cypress Street, a Public Service trolley waits on Millburn Avenue at the end of the line to make the trip to Newark. Morris Traction Company had not yet run their joining line from Millburn center. The sign advertises Breat's Hotel, which may have been one of the several hotels further up Millburn Avenue.

By 1915, the trolley from Millburn center connected with the Public Service trolleys at Maplewood loop just across the east branch of the Rahway River from Millburn. Here, motorman Arthur Looby and conductor Raymond Lyon of the Morris County Traction Company and an unknown workman wait to travel up Millburn Avenue for points west.

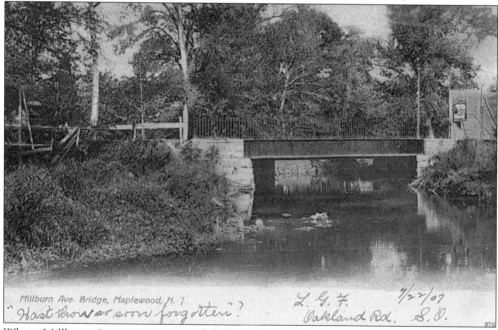

Millburn Ave. Bridge, Maplewood, N. J.
"Past hours are soon forgotten."?
L. G. F. 7/22/07
Oakland Rd. S. O.

When Millburn Avenue was extended from Vaux Hall Road to Springfield Avenue in Maplewood it was necessary to bridge the east branch of the Rahway River at the Maplewood - Millburn border.

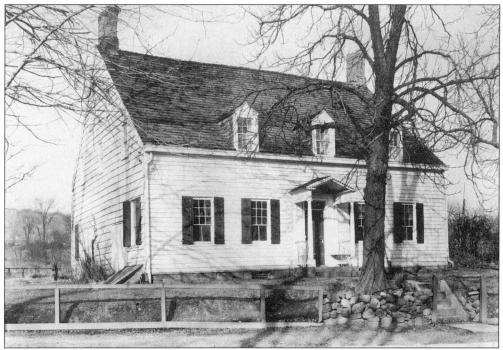

The Hessian House was constructed after 1730 from plans in the *Carpenter's Handbook*. It is believed that during the Battle of Springfield on June 23, 1780, two Hessian soldiers deserted from the attacking British army and hid in the attic. They were the progenitors of the Van Wert families long located in the area. Today, the house and garden are meticulously maintained by the private owner who in recent years constructed an appropriate addition to the right side.

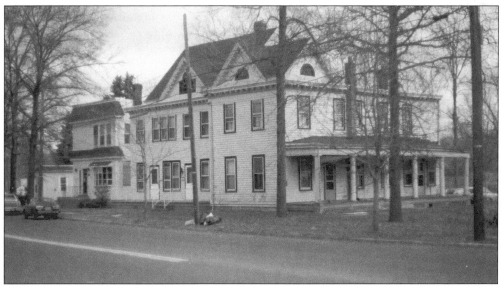

Around the turn of the 20th century, there were numerous small hotels in town that catered to summer visitors seeking cooler, cleaner country air. This one, on the south side of Millburn Avenue west of Norwood Terrace, was turned into small apartments. It was demolished in 1977 and replaced by a medical building.

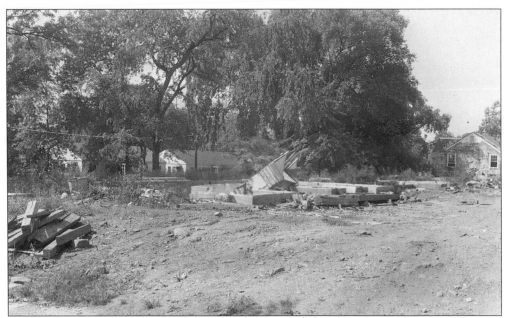

In 1947 the town purchased property on both sides of Millburn Avenue between Norwood Terrace and Reeve Circle on which temporary housing for veterans of World War II was constructed. As new housing became available in the town, the structures were gradually removed. Several are visible in the background while ruins of some are in the foreground.

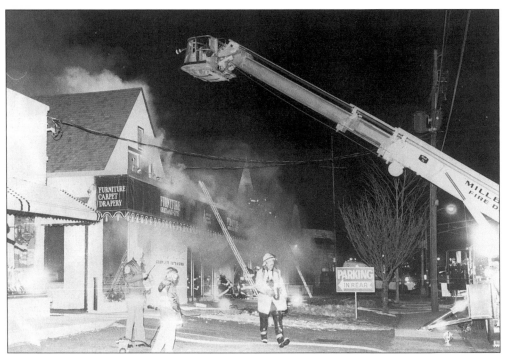

This Tudor style building on the northwest corner of Millburn and Wyoming Avenues housed a furniture store, children's shop, and Christopher's Luncheonette (formerly the Wyoming Sweet Shop). The complex was destroyed by fire Easter Sunday 1982.

Three
SOUTH MOUNTAIN
ESTATES

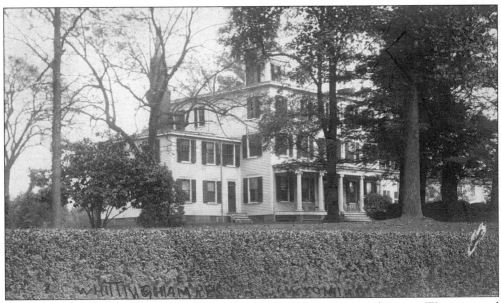

The Whittingham home stood on the north side of Millburn Avenue between Wyoming and Myrtle Avenues. The house was rumored to be part of the underground railroad during the Civil War. The building was torn down in the late 1940s for the construction of the Lord & Taylor department store.

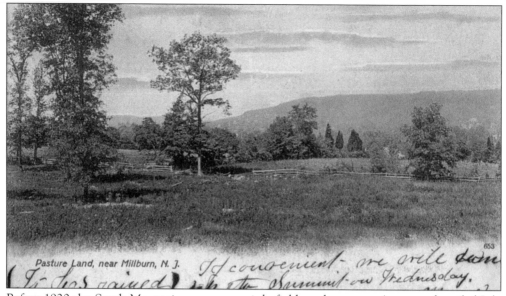

Pasture Land, near Millburn, N. J.

Before 1920 the South Mountain area was mainly fields and pastures. A postcard mailed July 26, 1909, with the South Mountain (a.k.a. Newark Mountain) appearing in the background, clearly shows the open area.

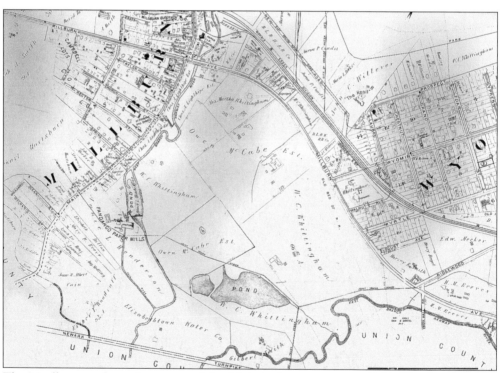

The Mueller map shows the extent of the Whittingham property in 1906. The family owned much of what is South Mountain Estates today. Sometime after 1906 the family also secured the two tracts of the Owen McCabe estate and those of the Charles Lighthipe estate along the west branch of the Rahway River. This made the Whittingham ownership of the area complete.

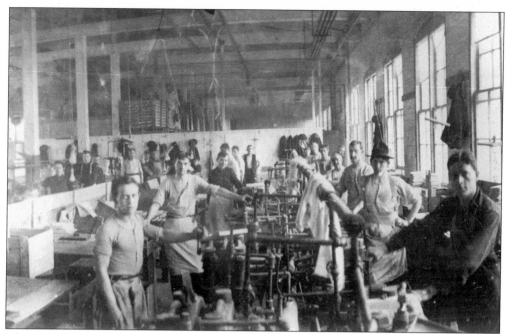

About 1898 George Burt moved his billiard ball factory to a site in South Mountain near where the school is now located. The company was the largest producer of pool and billiard balls in the country. The factory workers are shown outside the factory. Note the white wall in the rear, which separated production from the polishing, packing, and shipping sections.

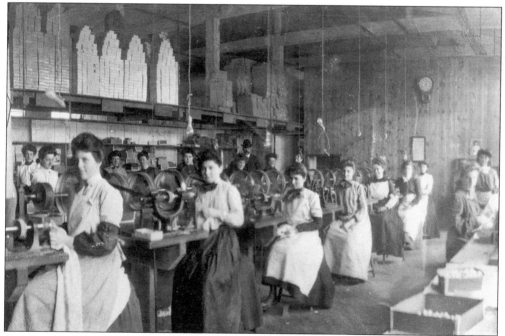

Female employees of the Burt Company are shown at their workstations for polishing and packing the billiard balls. The company was sold in 1903 and apparently was moved out of state at that time.

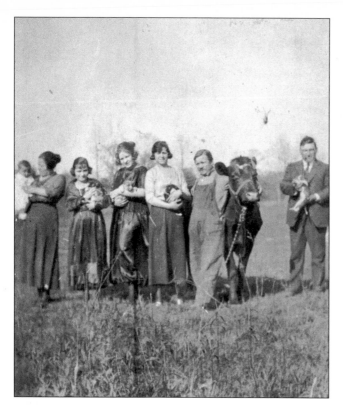

Many families living in and around Main Street used the area that is now South Mountain Estates for pasturing their livestock. Here, two women hold children, two others and a suited man hold piglets, and the family cow is also part of the group.

PIG PERMIT

BOARD OF HEALTH
MILLBURN. ESSEX COUNTY, NEW JERSEY

No._____ _____ 192___

𝕿𝖍𝖎𝖘 𝕮𝖊𝖗𝖙𝖎𝖋𝖎𝖊𝖘 *that* _____
<div align="center">NAME OF OWNER</div>

<div align="center">ADDRESS</div>

is entitled to keep _____ *Pig____on his premises*

located on _____ *in the Township of Millburn*

for the year 192____when this license expires.

_____ _____
<div align="center">SECRETARY PRESIDENT BOARD OF HEALTH</div>

By the 1920s the town's Board of Health was controlling the number of pigs that residents could keep. Today, maintaining any farm animals including horses is prohibited in town.

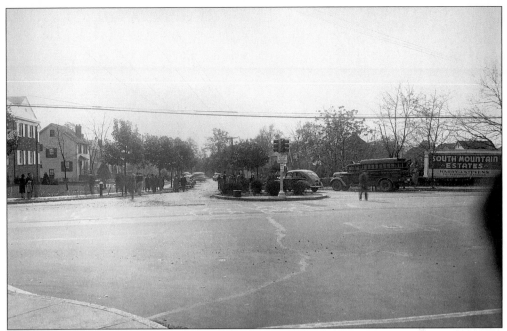

In 1922 the widowed Martha Whittingham sold much of her property for development. By 1924, roads had been built and construction of homes was started. A view of the Wyoming Avenue entrance to South Mountain Estates about 1941 prominently displays the billboard of Realtor Harry J. Stevens whose office stood further to the west on Millburn Avenue.

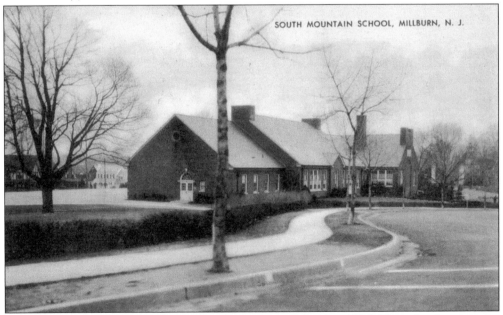

The town purchased the site for the South Mountain School in 1924. The school, as seen on this postcard, was opened in September 1936. Prior to that, the children attended the Wyoming School. Students crossed the railroad tracks either at Wyoming Avenue or by using a footbridge at Myrtle Avenue. South Mountain School has been enlarged several times, first in 1948 and most recently in 1997.

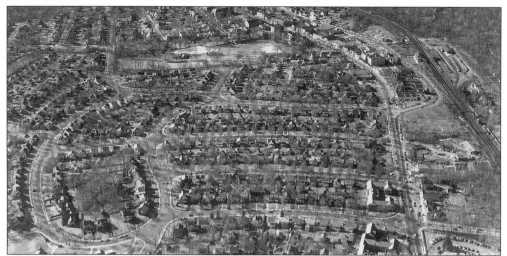

A 1954 Fairchild Aerial Survey, Inc., shows a portion of the fully developed South Mountain Estates. Millburn Avenue is on the right and Taylor Park is in the top center of the photo.

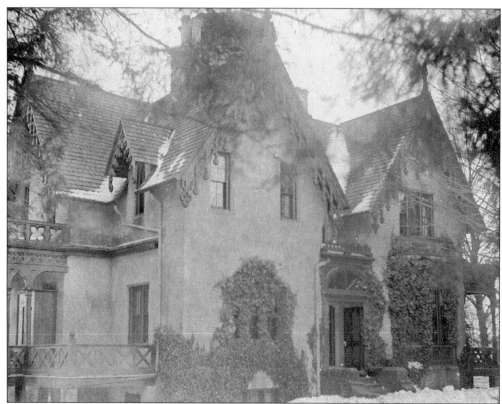

The home of Dr. Edward Thomas Whittingham stood on Rawley Place. It was built in 1868 and demolished after 1960 to build an enlarged parking lot for the stores at 290 Millburn Avenue. His marriage to Caroline Condit joined two prominent Millburn families of the 19th century.

Mrs. John Taylor was active in many organizations but she is best known for her generosity in giving Taylor Park to the community. Named in memory of her deceased husband, she purchased the 13 acres from Elizabeth Whittingham who aided the project by selling the land at a reduced price.

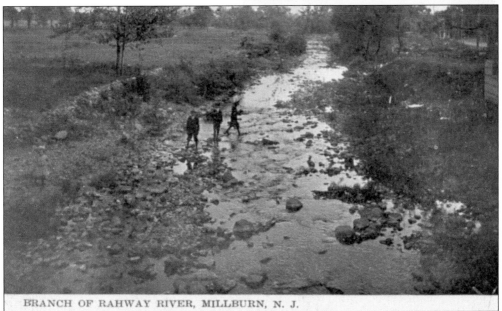

BRANCH OF RAHWAY RIVER, MILLBURN, N. J.

The open land Mrs. Taylor purchased in 1923 was largely flat with the west branch of the Rahway River running through it. Most tenements and mills on the site had long been demolished. Here, in 1914, schoolboys and a young girl play in the river as viewed from the Millburn Avenue bridge.

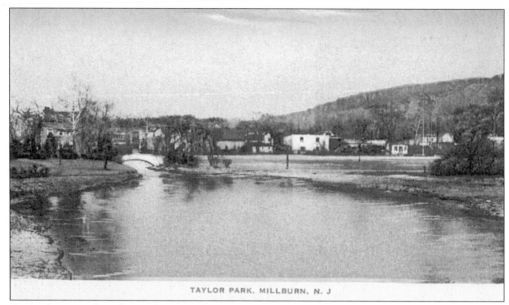

TAYLOR PARK, MILLBURN, N. J

An early view of Taylor Park across the pond toward Millburn center and the mountain shows the original open expanse. At first there had been homes along the east side of Main Street and later, several mills were built. By the 1890s there were also some tenements. All remaining buildings were demolished when the park was created.

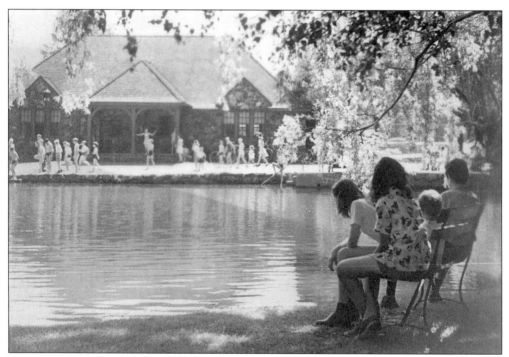

A view in the 1950s shows the first stone recreation house built in 1934 in the background. A group of youngsters are ready for a swim in the pond.

56

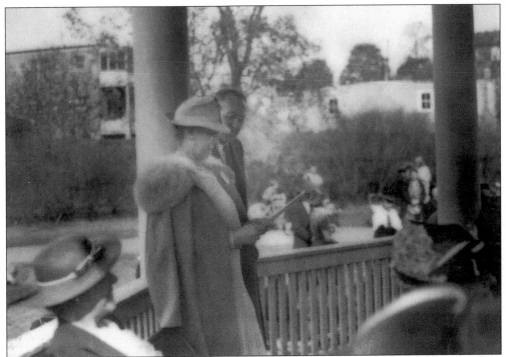

A bandstand stood on the Millburn Avenue end of the park where the gazebo is today. Here is Mrs. Taylor perusing the program for an affair held June 15, 1940.

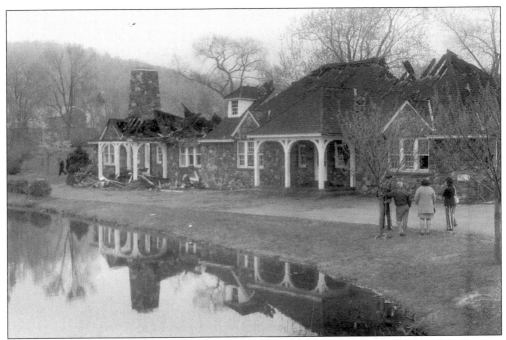

In the 1960s the recreation building was destroyed by fire. In addition to the loss of the facility, all of the extra copies of the 1957 Millburn centennial book that were stored in the attic were destroyed.

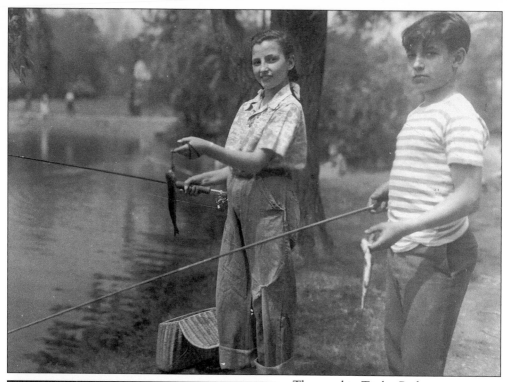

The pond in Taylor Park accommodated all sorts of activities in the 1940s. Ice skating was a winter pastime here, as well as at Diamond Mill Pond in South Mountain Reservation and at North Pond on Lake Road in Short Hills. In the spring youngsters could fish, as can be seen here and in summer it served as the town swimming pool.

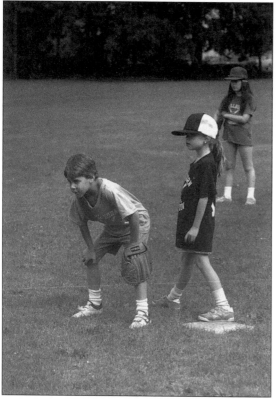

In more recent times the recreation department sponsors many youth programs such as T-ball.

58

Four

BROOKSIDE DRIVE
AND SOUTH MOUNTAIN
RESERVATION

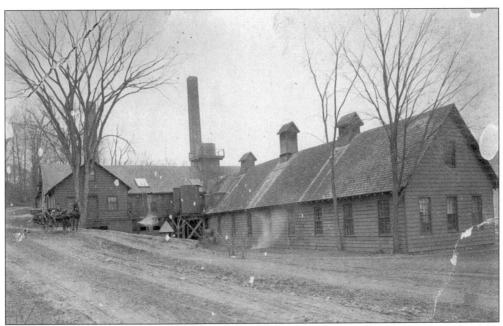

The first mill on this site on Brookside Drive was constructed before the Revolution and burned in the early 1800s. The succession of owners of the rebuilt mill included Samuel Campbell, Abraham and Jonathan Parkhurst, Israel D. Condit and eventually the Diamond Mills Paper Company, which produced colored tissue paper. In later years the mill was rebuilt of brick and enlarged.

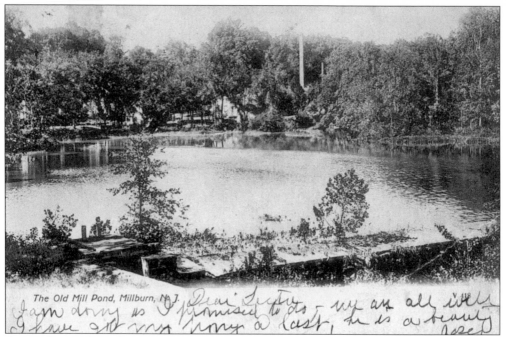

The Old Mill Pond, Millburn, N.J.

Across the pond can be seen the Diamond Paper Mill. This pond, however, supplied water to the Lighthipe Mill, which stood on the riverbank south of the railroad, and north of today's Essex Street. The stone walls of the pond were still visible in the 1940s. Today, two athletic fields for the Millburn Middle School cover the site.

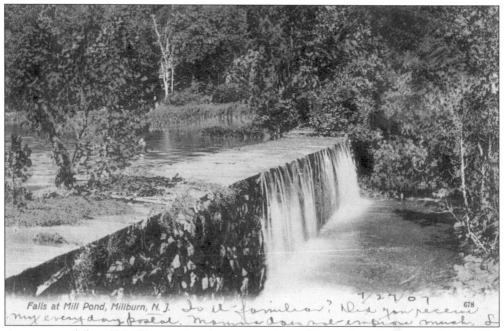

Falls at Mill Pond, Millburn, N.J.

As you passed the old Millburn railroad station on Main Street, directly to the right could be seen these falls of the Lighthipe Pond. Today, the bridge on the footpath behind the library and athletic fields looks down on the site.

Can You Use This Factory?

FOR SALE OR LEASE-- POND AND VALUABLE WATER RIGHTS ARE INCLUDED

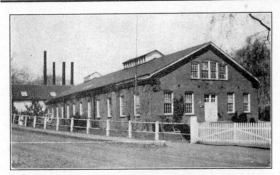

OVER 20,000 SQ. FT.

Most of Which is

GROUND FLOOR SPACE

Conveniently Located in the New Jersey Commuting Area Only 17 Miles from Manhattan

MILLBURN, NEW JERSEY lies just beyond the Oranges on the line of the Lackawanna Railroad. 30 trains each way daily and bus service to Newark and all points within a wide radius. The Lackawanna's new electric trains will be in operation by the time you move in. Main trucking highways in all directions. Plenty of good labor available.

THE WATER RIGHTS ALONE ARE WORTH THE PRICE AT WHICH YOU CAN BUY THIS FACTORY. There is no pollution of the water possible above this plant. The west branch of the Rahway River flows through the Essex County Park Reservation and is drawn on by the City of Orange for drinking purposes. The pond and water rights of this mill date back a hundred years or more. The water enters above second floor level.

LESS Than $30,000 Will Buy This Plant

But You Must Act Now!

This is your opportunity. Own your own plant and reduce your overhead.

I stand ready to give you personal service—Let me hear from you.

GEO. WRIGHT CAMPBELL

"Factories That Fit"

103 PARK AVENUE NEW YORK CITY
Telephone, Lexington 0345

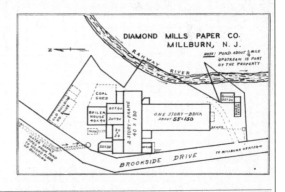

This 1930 Geo. Wright Campbell flyer advertised the Diamond Mills Paper Company factory for sale for less than $30,000. Water rights mentioned include those from the first pond in the reservation as well as those from ponds on Brooklawn Drive which form the brook on the south side of Glen Avenue west of Brookside Drive.

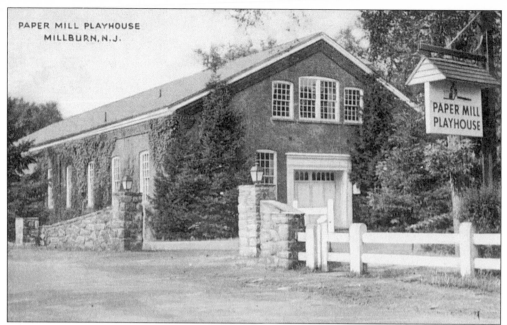

In 1934 the property on Brookside Drive was purchased by a newly formed theatrical organization which later was called the Paper Mill Playhouse. Antoinette Q. Scudder was the patroness and Frank Carrington served as director until his death on July 3, 1975. This is an early view of the playhouse. In later years a large dormer was built over the lobby section.

In the early years the lobby was filled with furniture and household items appropriate for the early beginning of the mill which operated here. A small art gallery was on the second floor. The Paper Mill Playhouse was designated The State Theatre of New Jersey in 1972 by Governor William T. Cahill.

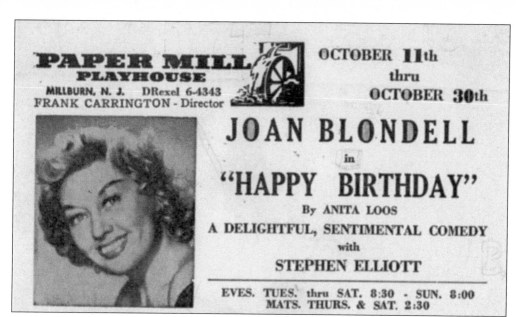

PAPER MILL
PLAYHOUSE
MILLBURN, N. J. DRexel 6-4343
FRANK CARRINGTON - Director

OCTOBER 11th
thru
OCTOBER 30th

JOAN BLONDELL
in
"HAPPY BIRTHDAY"
By ANITA LOOS
A DELIGHTFUL, SENTIMENTAL COMEDY
with
STEPHEN ELLIOTT

EVES. TUES. thru SAT. 8:30 - SUN. 8:00
MATS. THURS. & SAT. 2:30

Many well-known movie greats have often performed at the theater. This postcard promoting Joan Blondell in "Happy Birthday" is from 1955.

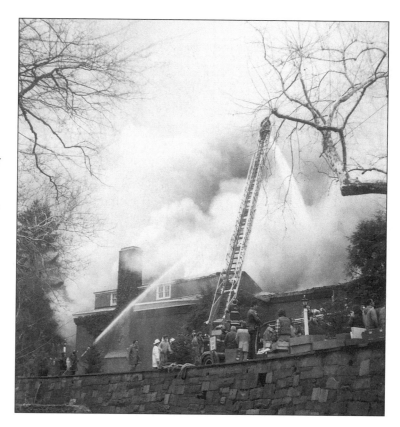

Fire struck the Paper Mill Playhouse shortly after noon on January 14, 1980. Starting behind the stage, the office section suffered damage but was mostly saved. The "shoe-box-like theater" (part of the old mill building) was destroyed. This photo shows the fire burning through the roof of the second floor above the lobby.

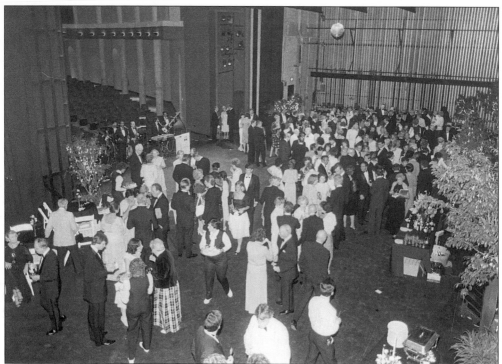

A gala was held for the official opening of the rebuilt theater on October 30, 1982. A cocktail hour was held on the stage from where the new interior of the theater was visible. An elaborate dinner in a tent and the premier production of "Robert & Elizabeth" followed it. Subscribers to the season of performances exceeded 30,000.

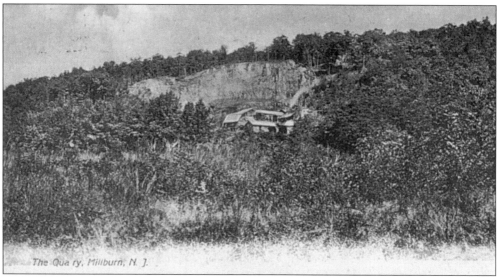

The Qua ry, Millburn, N. J.

In the late 1800s Charles A. Lighthipe opened a quarry for traprock at the end of the mountain. Part of the roadbed of the New Jersey West Line Railroad became the spur connecting the quarry to the Lackawanna Railroad. The triangular park at the eastern end of the Millburn railroad station parking lot and the bridle path into the reservation by Cape Court are reminders of the spur.

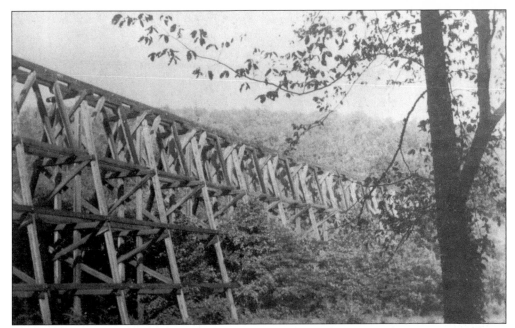

This trestle stood just before the first sharp curve on Brookside Drive at the entrance to what is now South Mountain Reservation. Built by the New Jersey West Line Railroad about 1870, the only section ever to become operational was the current branch of New Jersey Transit from Summit to Gladstone. The western stone abutment and the eastern dirt embankment are still visible from Brookside Drive.

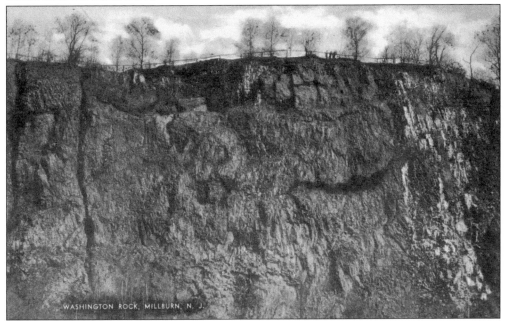

Essex County purchased the Lighthipe Quarry in 1913. The buildings were demolished and work was commenced on screening the bare rocks with plantings while fencing was placed at the crest to prevent accidents. Until fencing was placed at the base in recent years, the Millburn Fire Department rescued many climbers who tried to scale the cliff.

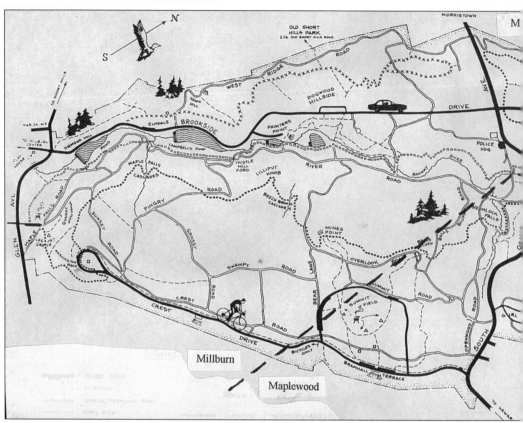

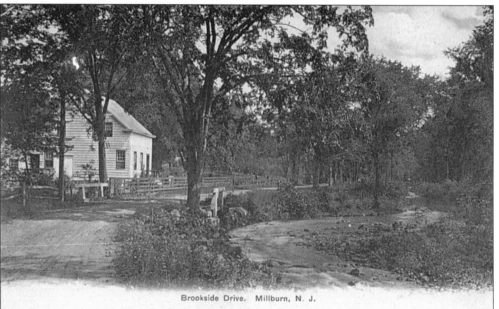

Brookside Drive. Millburn, N. J.

This dwelling stood between Diamond Mill Pond and the Campbell property in the valley. To the rear was a brook or flume that flowed into the Rahway River under the little bridge in the foreground.

66

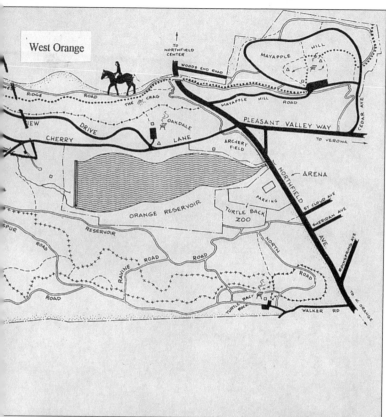

West Orange

The Essex County Park Commission began purchasing land to form the South Mountain Reservation in 1895. By 1920 when the last purchase was made, including many properties of early settlers, the park comprised 2,064 acres, of which 853 acres are in Millburn. The Millburn section is to the left of the dotted line on this map.

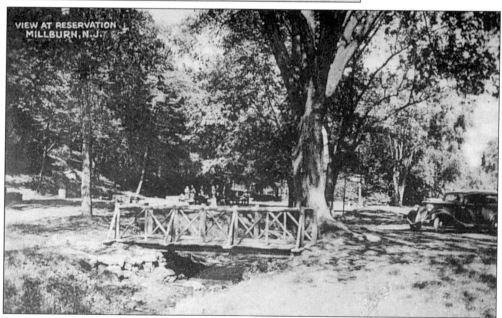

VIEW AT RESERVATION MILLBURN, N.J.

After Essex County demolished this small dwelling below Campbell Pond, the Elmdale picnic area was created on the site. This 1936 post card scene shows the bridged flume with picnickers in the distance. The car appears to be a 1933 Chevy.

Samuel Campbell (pictured with his wife) was born in Scotland and in 1756 received a grant from the Crown for 120 acres in the valley of the west branch of the Rahway River. He established his "Thistle Mill" in 1790 and produced paper that was used for early U. S. bank notes. Reputedly, he referred to his "mill-on-the-burn," meaning mill on the river or riverbank; thus the origin of the name Millburn.

The Campbell home stood across the road from the Thistle Mill. In 1899 the 145-acre property was condemned by the Essex County Park Commission and acquired for $33,123. The house was demolished. In a 1957 letter Campbell descendants stated that fireplaces in their home in Atlanta, Georgia, had come from the family home in Millburn. The site is occupied today by a small pump house of the Orange Water Department.

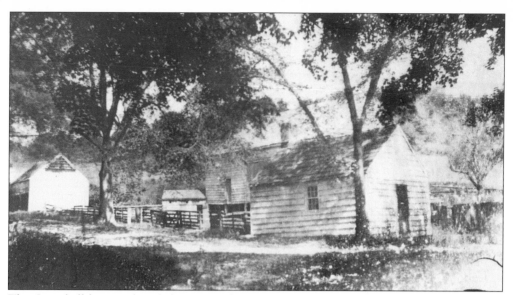

The Campbell barn and wash house stood at the foot of Old Hollow Road. The first Sunday school in New Jersey was started in the wash house in 1818. The site today is the parking lot across from the dam on Campbell's Pond. The pond is now owned by the City of Orange, which also owns much of the riverbed and other lands for a total 91 acres in Millburn.

The Thistle Mill bridge was located just beyond the northern end of Campbell Pond. The picture is from the Farrington/Blood family who resided at 97 Old Short Hills Road for over 80 years. In the 1930s the CCC constructed a more substantial log bridge. It stood until the 1950s when it was washed away in a flood. The site is by the rhododendrons on the curve north of Campbell Pond.

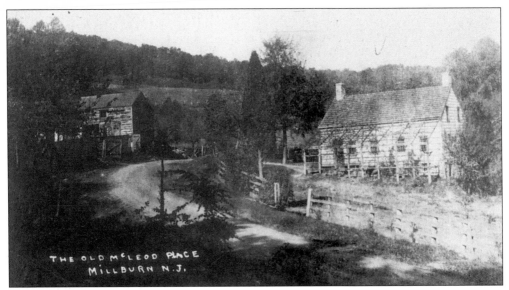

THE OLD McLEOD PLACE
MILLBURN N.J.

The MacLeod farm occupied the field to the right of the long hill just past the Thistle Mill bridge and part of the field above and to the left of the road. After being purchased by the Essex County Park Commission , extensive plantings of hemlocks were made. None are visible today.

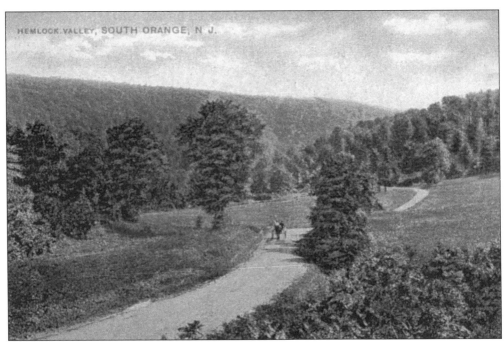

HEMLOCK VALLEY, SOUTH ORANGE, N.J.

After the demolition of the farm buildings, the road was improved from the original rutted, dirt farm lane. It became a popular pleasure ride, particularly on weekends, for horse-drawn carriages.

70

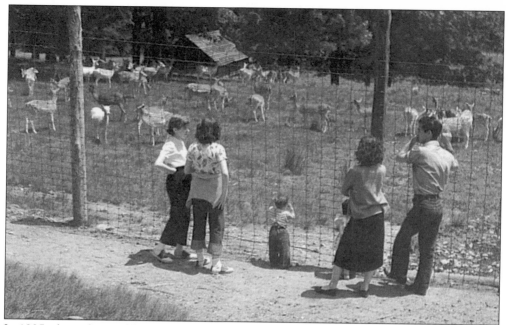

In 1935 a large deer paddock was constructed north of South Orange Avenue with parking and a stone refreshment stand on Valley View Road. In 1959, the deer were moved to a paddock off Crest Drive on the top of the mountain. Cherry Lane was rerouted in 1960 to connect directly with Brookside Drive. The paddock on the mountain was closed in 1980 and the deer sold to a park in Virginia.

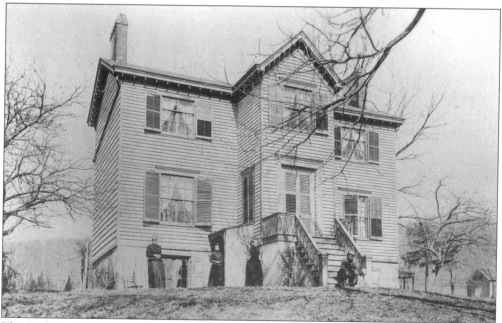

The Frisby home stood on the north side of South Orange Avenue. The property ran from the bluff above the west branch of the Rahway River to the crest of Second Mountain. When the county purchased the land, Mrs. Frisby was given a life tenancy in her home and it was demolished after her death in 1913.

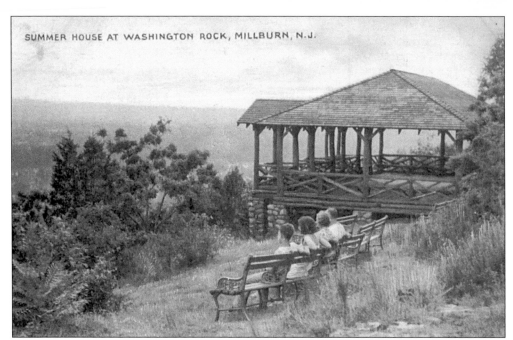

Three picnic shelters were constructed of chestnut in 1908, including this one overlooking Millburn with views to the south. The shelter was a favorite site for carving initials. The structure was replaced in recent years by a cement platform. During the Revolution and the War of 1812, signals to alert the militia were located at this location.

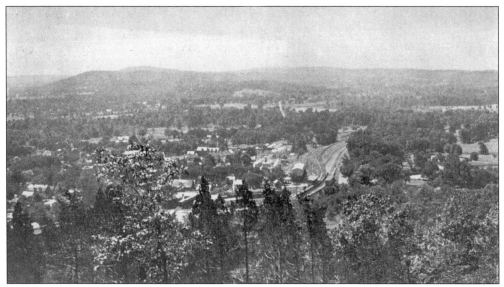

A 1901 photograph taken from Washington Rock shows Millburn center and heavily treed areas to the west. Just right of center can be seen the coal shed of the Millburn Coal & Ice Company and the tracks of the Delaware, Lackawanna, and Western Railroad.

Five
OLD SHORT HILLS ROAD AND VICINITY

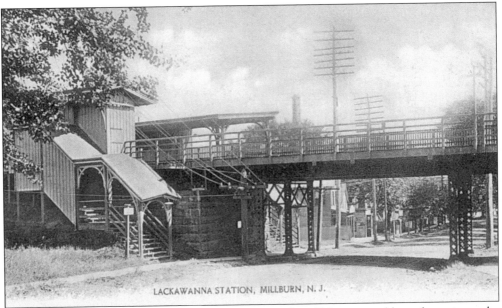

LACKAWANNA STATION, MILLBURN, N. J.

Looking down Old Short Hills Road toward town in the 1890s, you could see the stairs to the westbound tracks of the second Millburn railroad station. The building reputedly was put together from some storage buildings erected while the roadbed was being realigned.

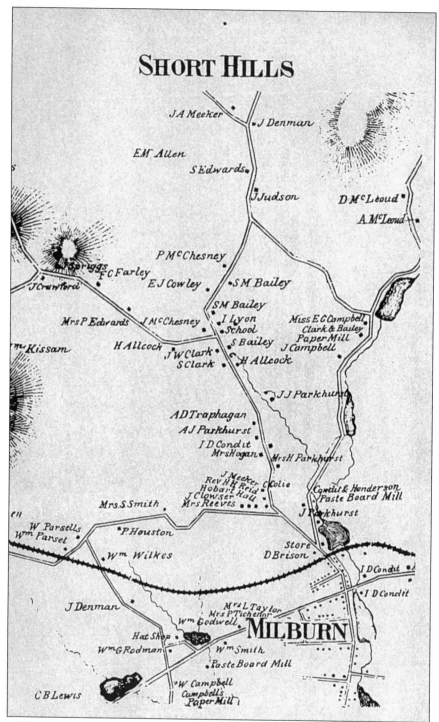

SHORT HILLS

On this 1859 map, Old Short Hills Road runs up the center from the railroad. Hobart Avenue and Parsonage Hill Road extend to the left. To the right is Brookside Drive with the three ponds and Old Hollow Road that today is no longer a through street. Many of the family names shown had been in town for over 100 years.

74

Cornell's meat market was on the east side of Old Short Hills Road at the intersection with Brookside Drive. The building had an interesting and varied history. Built as a home circa 1870, the first floor became the market, was then returned to a dwelling, and in 1938 became the first home of the Millburn Free Public Library. A small triangular park now occupies the site.

The Brison farmhouse was built in the early 1800s. In the 1930s and until 1962 the building served as the Millburn Inn, a family restaurant known for its hot cinnamon buns. The Board of Education demolished the building in order to accommodated the 1964 addition to the Millburn Middle School.

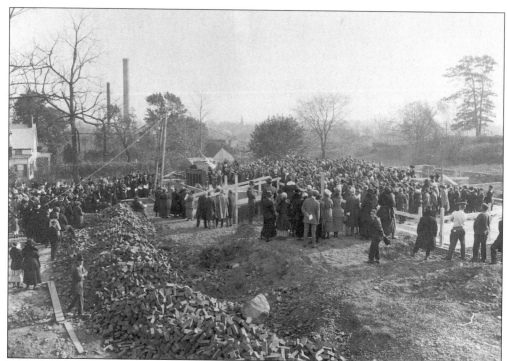

On October 26, 1921, a large crowd gathered on land that had been part of the Brison farm. The occasion was the laying of the cornerstone of the new high school on Old Short Hills Road, replacing the Short Hills High School on Hobart Avenue. All of the school children participated in the ceremony and addresses were made by William Runyon representing the Governor, and Walter R. Hine who was chairman of the Millburn Township Committee.

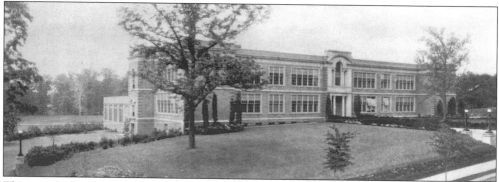

The new high school was opened in September 1922 and consisted of twelve rooms and a gymnasium/auditorium. Over the years, classrooms, an auditorium, and a second gymnasium have been added. An annex was erected in 1964 and a complete renovation of the old building was completed in 1980. The building is now the Millburn Middle School.

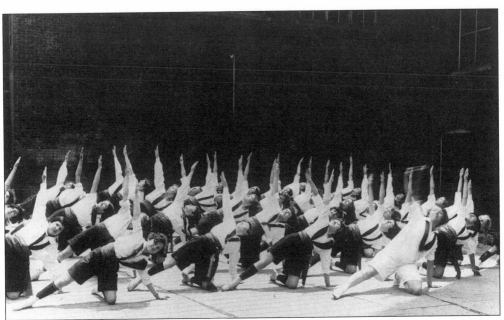
A picture from the early 1930s shows girls in an outdoor gym class doing their group exercises.

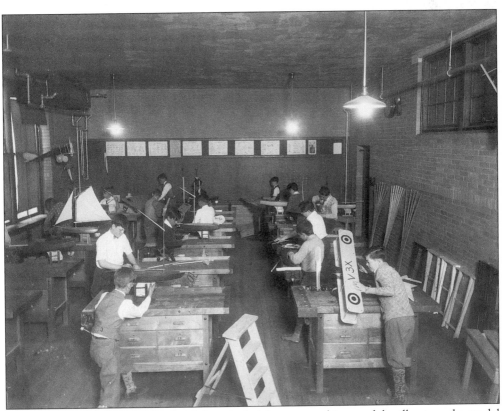
In the wood shop at the high school, boys in knickers are making model sailboats and a model of a World War I airplane.

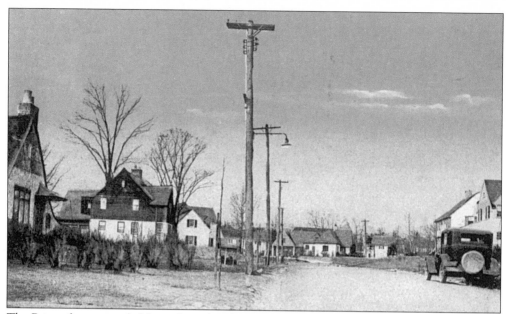

The Brison farm extended from the railroad to Hobart Avenue and from Old Short Hills Road to the Hartshorn estate. The land behind the new high school was sold for development and the Knollwood (or Whitney Road) section resulted. This postcard, mailed in 1935 shows English Tudor homes built in the 1920s, newer colonials surrounded by little vegetation, and an unpaved Haddonfield Road.

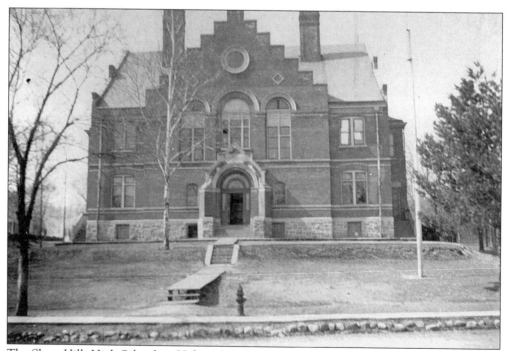

The Short Hills High School on Hobart Avenue opened in 1893. Not only was it the first high school in the town, but it was the first modern brick school. It was enlarged several times and in 1922 it became the Short Hills Grade School, also called the Hobart Avenue School.

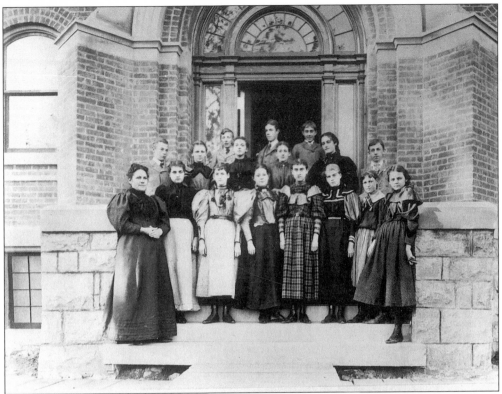

This picture at the Short Hills High School came from the Misses Keeney of Sagamore Road in 1956. It was taken in 1895 and shows what was possibly the full student body that year.

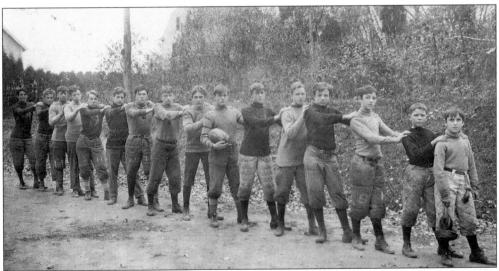

The first football team to represent Short Hills High School played a schedule of 11 games in 1908. They won two games, tied four, and lost five. Left to right: Mr. Smither, Bob Campbell, Guy Bosworth, Harvey Meeker, Oscar Smith, Jack Van Ingen, Ed Ward, John Crozier, Jim Van Ingen, Bob Oliver, Wes Drake, Ross Meeker, Emmett Crozier, Fred McFadden, Elwood Marshall and Emerson McFadden.

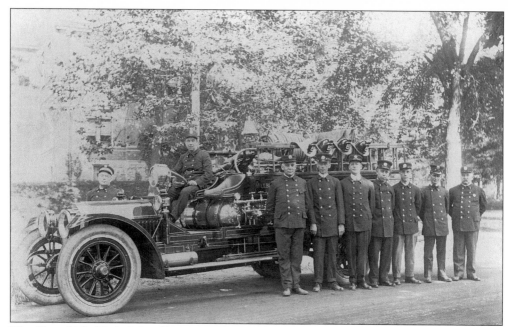

The Short Hills High School became a favorite backdrop for photographers. Here a company from the Millburn Fire Department poses in their formal uniforms.

This is the graduating class from the Short Hills High School on June 29, 1899. Students were: Martha Louise Woolsey, Gertrude Keeney, and George Campbell. The first student to graduate from the high school, based upon a 1909 annual report of the Board of Education, apparently was Sarah F. McChesney in 1896.

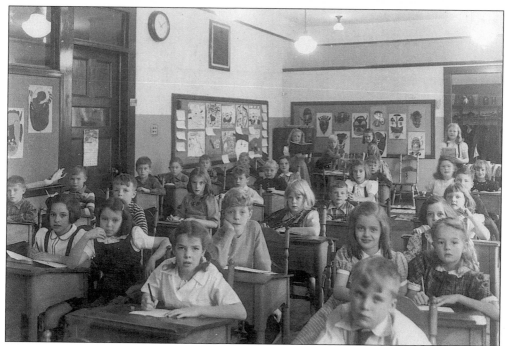

In 1943 the third grade class at the Short Hills Grade School posed for this picture.

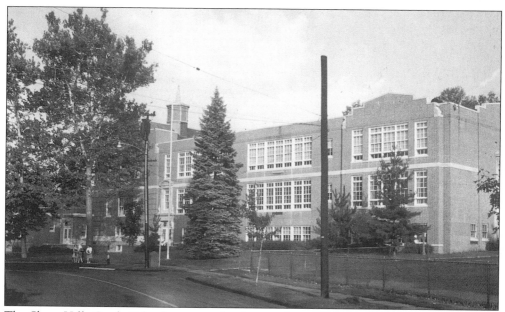

The Short Hills Grade School was completely gutted except for the auditorium, modernized, and a new kindergarten wing added in 1956. It was the most modern grade school in the system until Hartshorn and Deerfield Schools were opened. Teacher parking was in the rear and two playing fields were also on the property.

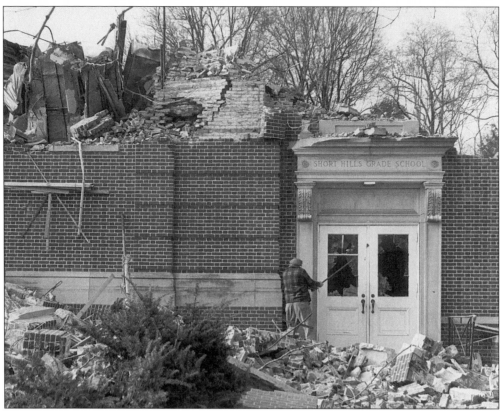

On March 4, 1984, Peter Christian took this photograph of the Short Hills Grade School being demolished. At the same time the South Mountain School was closed and leased to Summit Child Care.

By 1924 development of the Nottingham Road area had started. The Robin Hood Cottage was one of the first of six buildings built in the development which was designed by noted architect Bernhardt Muller who lived in the Elf Cottage at 2 Woodcrest Avenue. It was first used as a sales office for the development and later by L. Bamberger & Co. as a model designer's house. Today it is a private home. This postcard was mailed July 23, 1943.

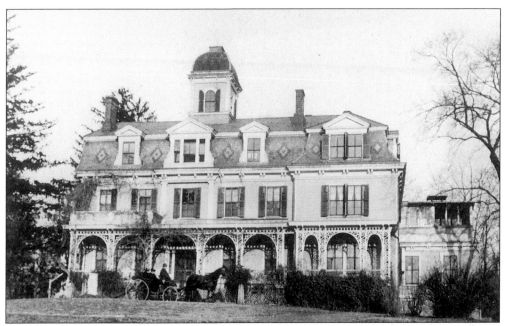

Edward Renwick built his large Victorian home at 140 Old Short Hills Road in 1867. A nephew of James Renwick who designed St. Patrick's in New York, he invented the chicken brooder and incubator. The house is now missing the cupola, mansard roof, and iron grillwork on the porch.

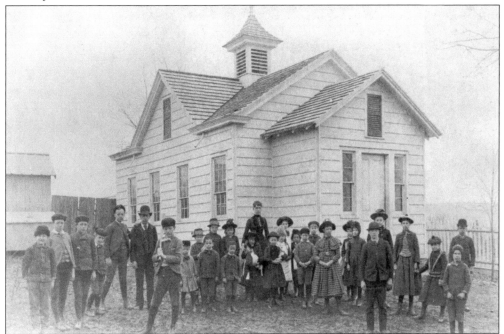

The Jefferson School stood on Old Short Hills Road directly opposite Parsonage Hill Road. This photo is dated 1888. A later picture shows the building with shutters. Note the great range in ages of the students as well as their attire. The school closed in 1895 when the new Washington School opened in the center of town.

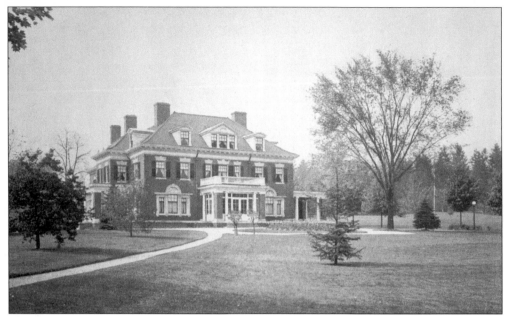

The John Taylor Estate stood on the western side of Old Short Hills Road. The Kenilworth Drive and Grosvenor Road area now occupy the site. The Taylors gave the Neighborhood House to the town and in 1924 Mrs. Taylor donated Taylor Park in memory of her husband.

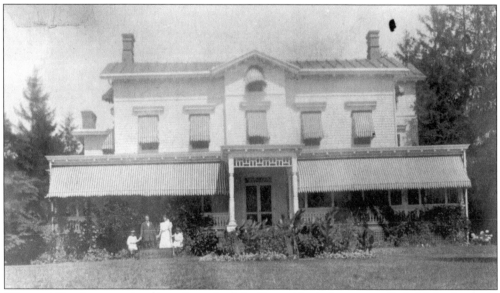

"Pleasant Days" was a colonial residence built by Pierre Noel who reportedly held the first polo game in this country on its grounds. He sold the property to the Feigenspan brewing family who in turn sold it to Joseph P. Day in 1907. An over-stoked furnace caused its destruction by fire in 1911. Old Short Hills Park and the surrounding dwellings are now located on the site.

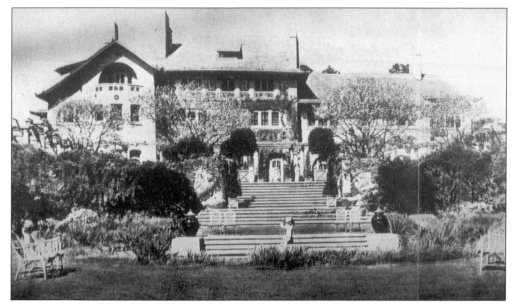

In 1914 a three-story, fire-resistant, stucco mansion with extensive gardens and outbuildings was completed from plans drawn by William Renwick. During the rebuilding, the Day family lived in the remodeled caretaker's cottage. The home stood until the property was sold following Mr. Day's death in 1957. Today, Old Short Hills Park occupies a large portion of the property.

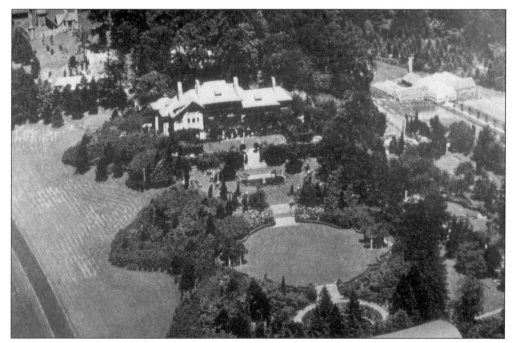

The gardens at the Joseph P. Day estate were some of the most elaborate in Short Hills and included fountains, statuary and a colonnade. A large greenhouse was located on the east side adjoining the South Mountain Reservation.

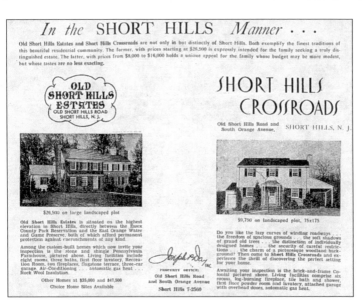

In the late 1920s, Day began developing the northern portion of his property, which he named "Old Short Hills Estates. " In the 1930s, development of Crossroads was begun on the northwest corner of South Orange Avenue and Old Short Hills Road. Lot sizes and homes were smaller at Crossroads so that young couples would have the opportunity to buy in Short Hills.

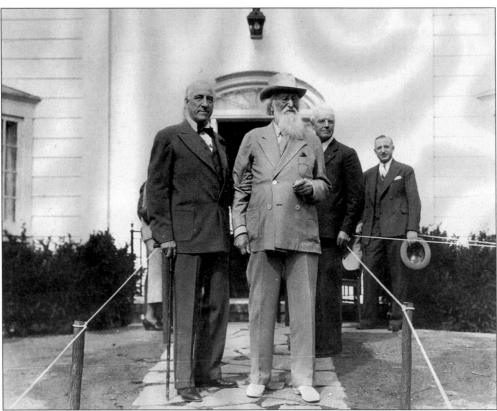

Joseph P. Day joined with General Properties, Inc. in the mid-1930s. This was a corporate entity through which architect Marcel Villanueva had developed various areas including Cross Gates in Madison and Short Hills. The picture shows Mr. Day and a Stewart Hartshorn, the man with the beard, following the ceremony commemorating the first house completed under the joint arrangement.

Six

GLENWOOD

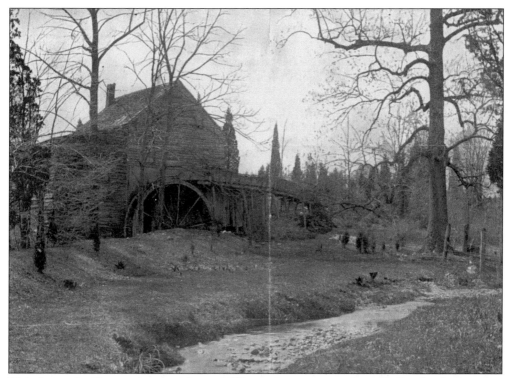

This deserted mill was a lonely sight on Millburn Avenue across from St. Stephen's Cemetery for many years. The mill was started by Joseph, John and William Smith and produced binder board until 1872. The Millburn High School athletic field now occupies the site.

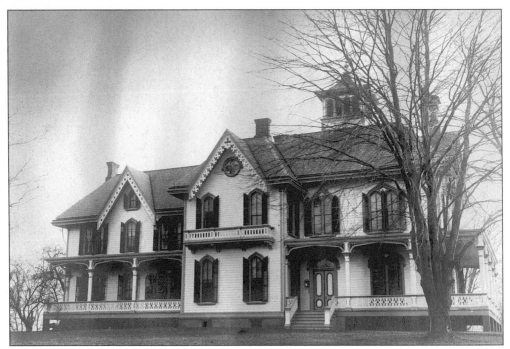

The Wellington Campbell home sat on a rise at the southeast corner of Short Hills and Millburn Avenues. It was probably constructed in the late 1850s. To the rear, on the bank of the stream forming the border with Springfield, stood the Wellington Campbell Mill. The ruins are still visible today.

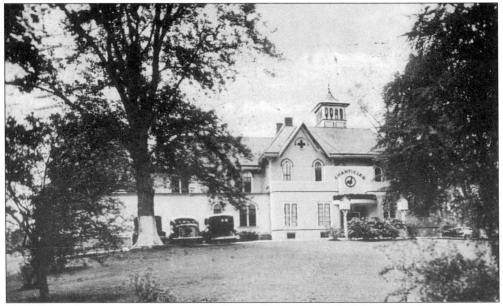

The Chanticler, a restaurant, occupied the Wellington Campbell home in the early 1930s. Over the years the exterior has been modernized. A postcard from the 1940s shows portions of the original building. Today the Victorian structure is completely entombed by the modern additions but the shape of the original building is still evident.

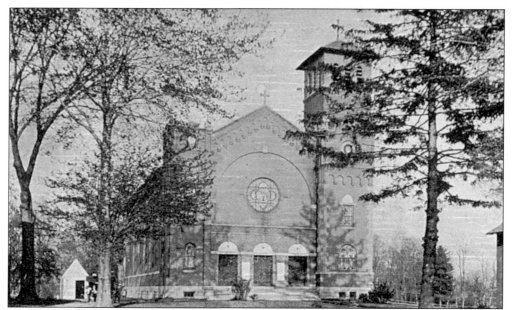

This brick Romanesque church of St. Rose of Lima (Roman Catholic) was built in 1912. It was renovated into the present colonial style structure in 1955. The first church building on the site was wooden and was moved from Springfield to the northeast corner of Short Hills and Millburn Avenues in 1880.

The first convent and first rectory of St. Rose of Lima on the present site were originally private homes. One of them, which had previously contained a hat shop, was converted into the convent and the first St. Rose of Lima School in 1869.

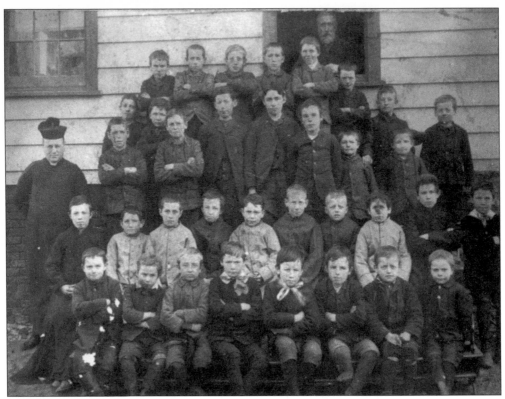

The boys attending St. Rose of Lima School pose for the camera outside the wooden building in 1896.

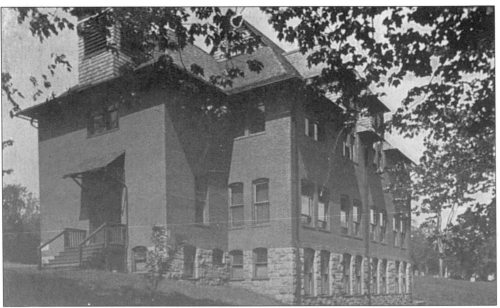

The two-room wooden school was superseded by this brick structure. After the present building was constructed around 1930, the old brick school building became the convent.

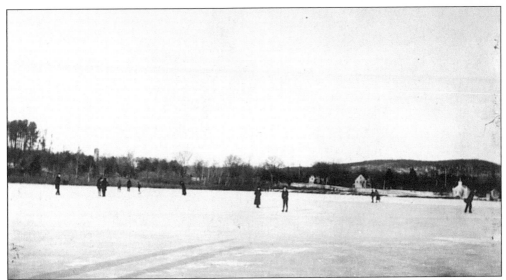

The Wellington Campbell Pond occupied a large part of the area on the easternmost portion of Meadowbrook Road and surrounding streets. This pond supplied water to the mill that stood behind the Wellington Campbell home. It was a favorite place for ice skating.

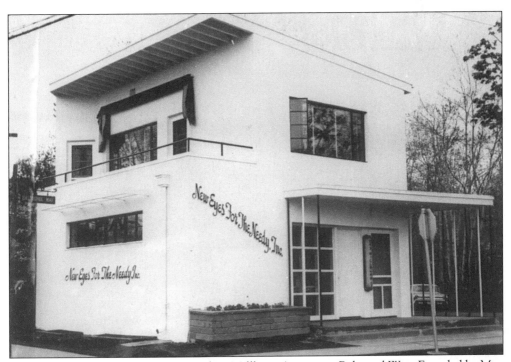

New Eyes for the Needy, Inc. is located on Millburn Avenue at Baltusrol Way. Founded by Mrs. Arthur E. Terry in 1932, it collects and redistributes used eyeglasses worldwide and buys new prescription eyewear for needy Americans. New Eyes first operated out of Mrs. Terry's home, then moved to Christ Church's Benedict house in 1950, and this building was purchased in 1963.

Looking up Baltusrol Way about 1910 the rural look is obvious. Only a few houses and trees are visible and, although there are sidewalks, a dirt road is still the norm.

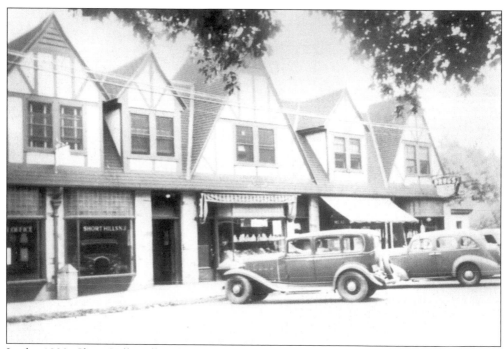

In the 1930s Short Hills Village had angle parking and the post office was in the easternmost Tudor style store. At the turn of the 20th century a nursery had been located on this site with the Short Hills stable and Short Hills firehouse just down the road.

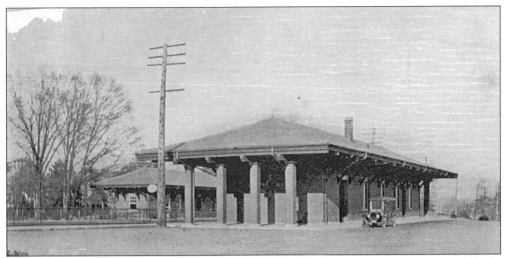

This new station of the Delaware, Lackawanna & Western Railroad was built about 1908 on the eastbound side of the tracks. It contains a large waiting room, freight room and ticket office. To prevent people from crossing the tracks, iron fencing was placed between the tracks. A smaller building with waiting room, constructed on the westbound side, is now occupied by the Millburn-Short Hills Historical Society.

Miss Cora Hartshorn and the family chauffeur, Joseph Collins, are standing at what is today the start of Forest Drive South. Miss Cora Hartshorn was the daughter of Stewart and Joanna Hartshorn.

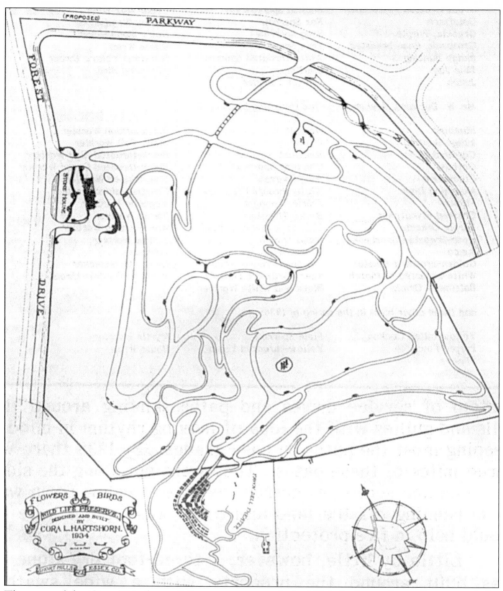

The map of the Cora Hartshorn Arboretum was made in 1934. It shows the pathways and the planned Fawn Dell Theatre. In 1923 Miss Cora Hartshorn's love of nature led her to have her father set aside 16.45 acres on a lovely hillside for an arboretum. Upon her death on October 17, 1958, she willed the property to the town to be run by an independent board.

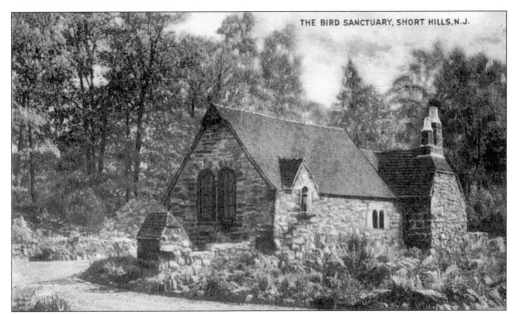

THE BIRD SANCTUARY, SHORT HILLS, N.J.

In 1931 Bernhardt Muller, a noted architect of the day who resided in the Elf Cottage on Woodcrest Avenue, designed the Stone House. The building, constructed of stone from the Hartshorn quarry in Springfield, was completed in May 1933. It was enlarged in 1972.

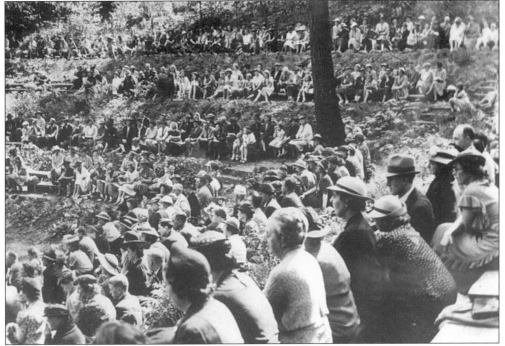

Miss Cora Hartshorn, without a hat and appearing at the bottom center of the photograph, is watching a performance at the Fawn Dell. The theater was christened on May 7, 1938, with a program by Anita Zahn's 200 dancers. The site is one of the terminal moraine kettle holes found throughout Short Hills. It was named for three little fawns that were seen frolicking there. The theater seats 600 people.

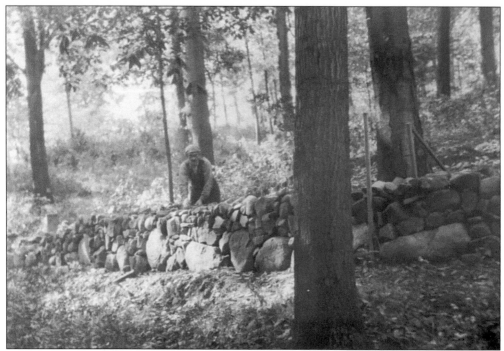

Benny, Miss Cora Hartshorn's mason and handyman, is shown building the stone drywall at the Arboretum. The area had often been swept by fire, usually started by sparks from passing steam trains that ignited leaves and dry foliage. The wall was built to prevent such destruction.

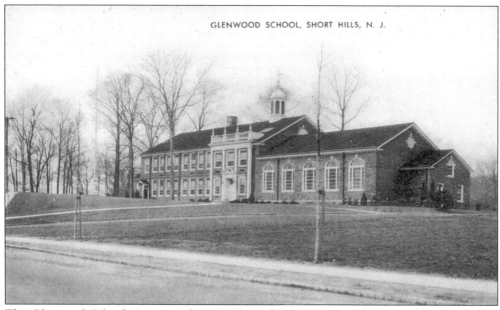

GLENWOOD SCHOOL, SHORT HILLS, N. J.

The Glenwood School was erected in 1939. At the time it was the fifth public elementary school in Millburn Township. Over the years, several additions have been made, the most recent in 1997.

Seven
SHORT HILLS

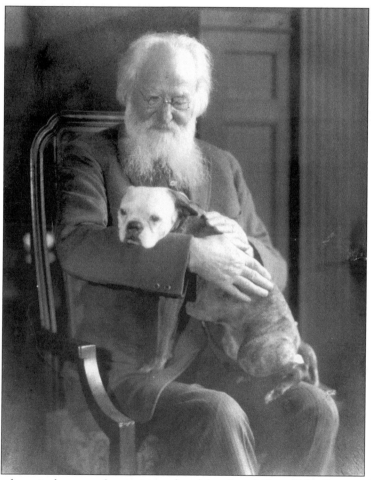

Stewart Hartshorn is the man who envisioned and developed Short Hills. Born in 1840, he had acquired a patent for the spring window shade by the time he was 24 years old. As his business grew, his great desire was to create an "ideal community." This led him to settle in Springfield in 1871 and ultimately to purchase land in Millburn to build his Short Hills Park. Here he poses with his pet Boston bull terrier at Christmas in 1924.

HARTSHORN'S SHADE ROLLERS.

Ladies—in Buying your Window Draperies,

Be sure you get HARTSHORN'S SELF-ACTING SHADE ROLLERS. They have no cords or balances to tear out shades and interfere with window draperies. They carry Shades easily to top of window, do not get out of order, and are sold by all respectable dealers. They are in use in the Capitol, White House, and Public Buildings at Washington, the new Capitol at Albany, the Government and Municipal Buildings in N.Y. City, and in the better class of homes throughout the United States.

Dealers are requested to replace any rollers that fail to give entire satisfaction.

S. HARTSHORN, 486 Broadway, N.Y.

The shade company of Stewart Hartshorn rapidly achieved superiority in the industry. Here, a typical advertisement indicates the extent of the usage of the product in the country.

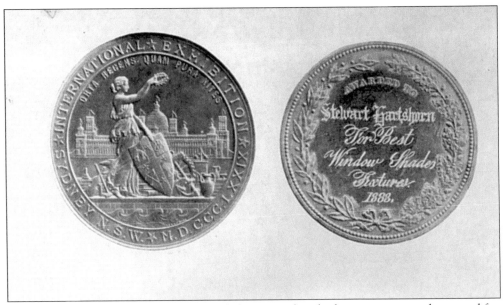

The company sold products worldwide. Exhibitions and trade shows were entered near and far. The medal on the left is from Sydney N.S.W. Australia in 1879; that on the right is dated 1888.

The first purchase of land made by Stewart Hartshorn was 13 acres for his own personal estate. The site occupied the eastern end of what are now Crescent Place and Great Oak Drive. The family moved into their first house in Short Hills in 1874.

The second home of the Hartshorn family stood where 18 Crescent Place is now. The mansion was dismantled in 1938 after the death of Mr. Hartshorn. The carriage house, later a studio and then a home, still stands at 26 Crescent Place.

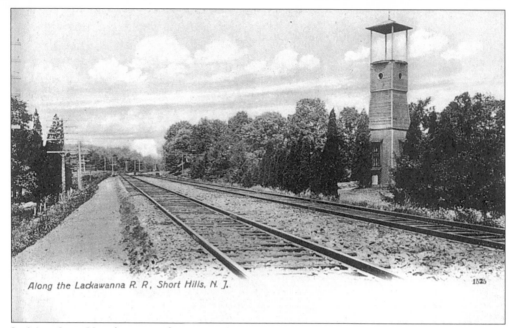

Along the Lackawanna R. R., Short Hills, N. J.

In Miss Cora Hartshorn's *Little History* she reports, "There was a fine spring and two lovely brooks on the place. Drinking water was brought twice a day from a spring, and water was also pumped up by a windmill near the railroad." The windmill stood between Great Oak Drive and the railroad at Pine Terrace East. This shows the windmill without blades.

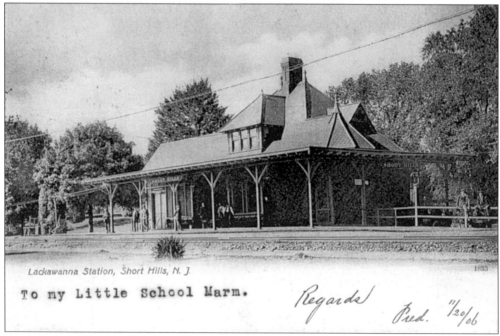

Lackawanna Station, Short Hills, N. J.

To my Little School Marm.

Regards Fred. 11/20/06

To get trains to stop at his village, Mr. Hartshorn built the first Short Hills railroad station in 1880. He hired and paid the stationmaster, Louis C. Goodrich, who also became postmaster when a post office was shortly installed in the station. On July 2, 1892, the station was deeded to the Lackawanna Railroad. The town now owns the current station.

The Music Hall was designed by noted architect Stanford White. Constructed in 1879, its purpose was to serve as the social center for the community. From the fall of 1882 until June 1884 worship services of Christ Church were held there. In later years the building was called the Casino and was home to the Short Hills Club until 1928 and later to the Racquets Club.

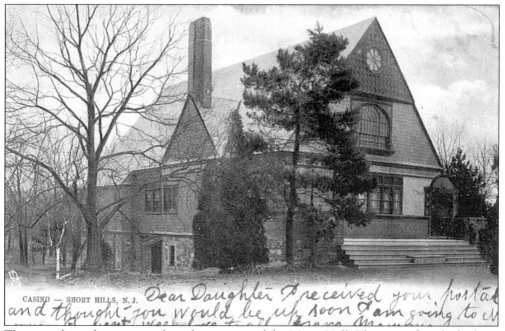

CASINO — SHORT HILLS, N.J. *Dear Daughter I received your postal and thought you would be up soon I am going to cl*

This rare photo shows west side and rear views of the Music Hall. The upper floor had a large auditorium which was entered through the double doors and had a well-equipped stage. For many years annual meetings of Millburn Township were held there as were locally produced musicals and plays.

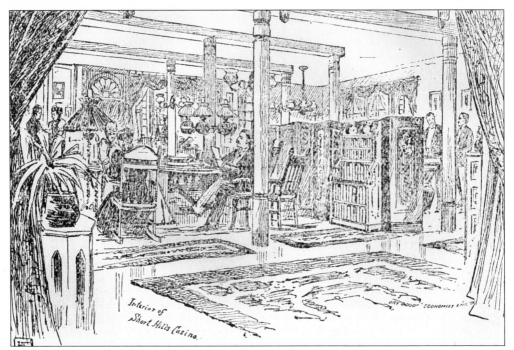

A number of etchings were made of Short Hills during the Victorian period. This one of the interior of the Casino was printed in Vol. VI. No. 19 of *The Short Hills Item*. The accompanying article read, "...billiards...bowling...card tables...and for a quiet hour's reading many cozy nooks are about the reading room which is well supplied with leading weekly and monthly periodicals."

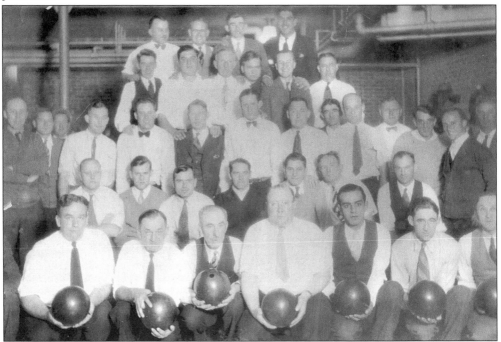

The men from the club's bowling league pose in the downstairs bowling alley.

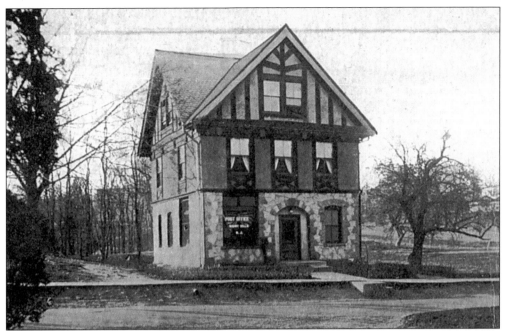

The post office was moved in 1885 to Mr. Goodrich's store, now 128 Hobart Avenue. It was again moved in 1913 to this building at 167 Hobart Avenue. In the 1930s the easternmost store on Chatham Road served for awhile until the current building was opened on May 10, 1937. Until 1948 there was no mail delivery in Short Hills and residents collected mail from their box at the post office.

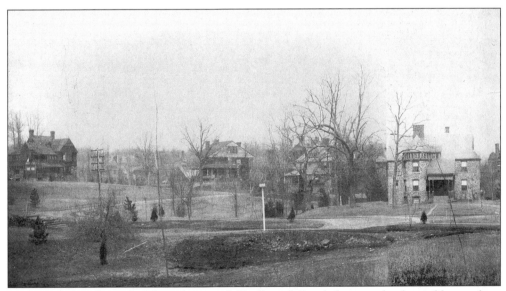

Looking across the railroad track toward Knollwood Road, houses clearly visible are from left to right: Hartshorn #20 (now demolished); One Park Place (1880) Shingle style; 14 Knollwood Road, Hartshorn #29 (1881) Queen Anne style; and 177 Hobart Avenue (known as "Greystone") 19th century Vernacular style. The chimney of "Redstone" can be seen on the far right.

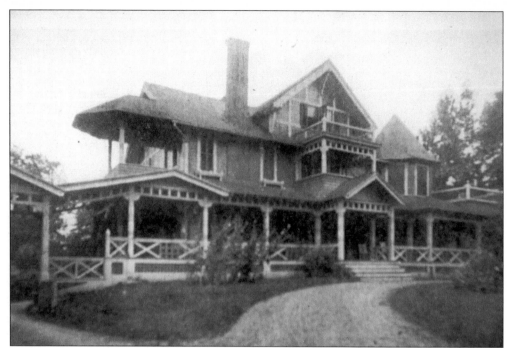

"Sunnyside" at 39 Knollwood Road was constructed in 1878. In the 1880s Mr. Hartshorn rented the cottage to William I. Russell, a commodities broker in New York. Liking the community, Russell decided to settle in Short Hills. The building is now greatly altered with all the porches removed and modern elements added to the right side.

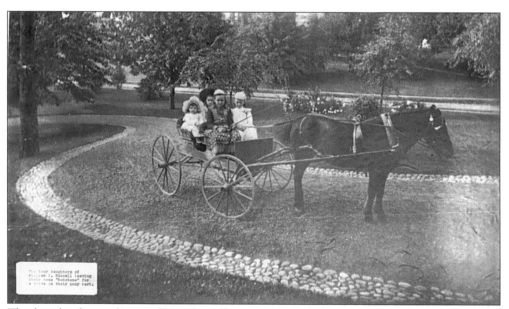

The four daughters of Mr. and Mrs. Russell were set up with their own pony and cart. Here they pose on the driveway in front of their new home.

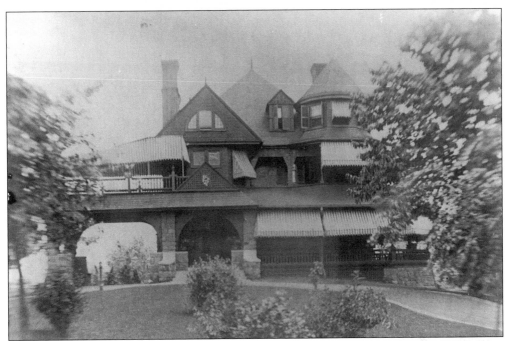

William Russell built "Redstone," which occupied several acres on the south side of Wells Lane at Knollwood Road. The name was spelled out over the front door. There was also a large carriage house to the rear.

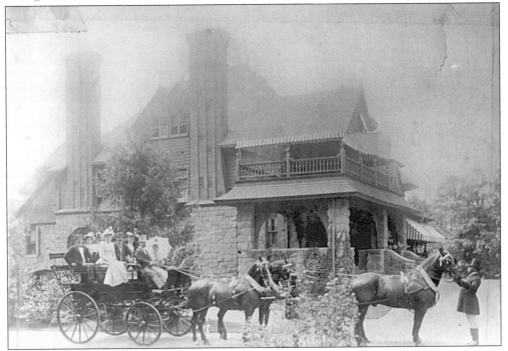

William Russell was very proud of his jet-black horses. They always drew attention in town when they went to be re-shod. A group poses in an open carriage for a picture before a Sunday drive.

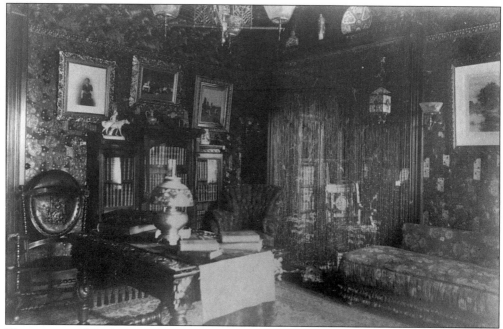

The interiors of the homes of wealthy Victorians were very ornate. In the library at Redstone, wallpaper, ceiling, carpets and upholstered furniture were all patterned. Any flat surface, even over the doorway, contained bric-a-brac and any wall large enough held a painting or framed photographs. Furniture was dark and heavy.

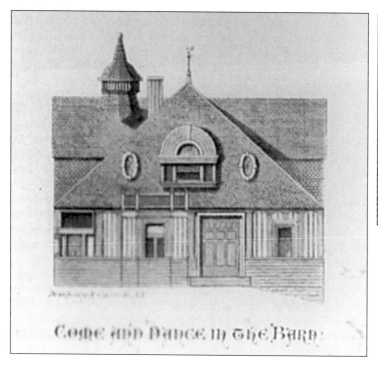

The Dance in the Barn.

The barn-dance given on Thursday night, Sept. 20, by Mr. and Mrs. William L. Russell was a pleasant incident of the season in the charming little borough of Short Hills, N.J. Mr. Russell's horses are the fortunate possessors of a large home, the gable front having a width of sixty feet, and their owner's invitation to "come and dance in the barn" was a welcome one. Doubtless the horses shared the spirit of hospitality characteristic of their master, and joined in the invitation with all their hearts; certainly not one said "neigh." A band of five pieces furnished the music, the musicians being stationed in the mow. Smilax surrounded the mow opening, twined every post and wreathed every window. Floral horse-shoes hung against each stall-post, and over the doorway was a ball of flowers three feet in diameter. The walls were hung with pictures of English hunting scenes, famous turf winners, etc. Canvas covered the floors, and the stalls, fitted up with seats, rugs, lamps and flowers, formed cosey retreats for tired dancers. The guests were received in the house, the lower part of which contained solid banks of flowers on every mantel and in every nook, and an awning was stretched to the barn. Dancing began at 9.30, and supper was served in the house at midnight. The floral decorations of the table were as attractive as those of the ball-room, the centre-piece being a representation of a pony tandem, with a dog cart and footman complete. The order of dances presented to each guest held a beautiful souvenir of the occasion in the shape of a horse's fore leg and hoof of solid silver, with a gold shoe, a gold pencil being concealed in the leg.—*The Tribune.*

The Short Hills Club.

Shown here is an invitation to a great social affair held at Redstone on Thursday, September 20, 1888. *The Short Hills Item* featured the event in the article above.

106

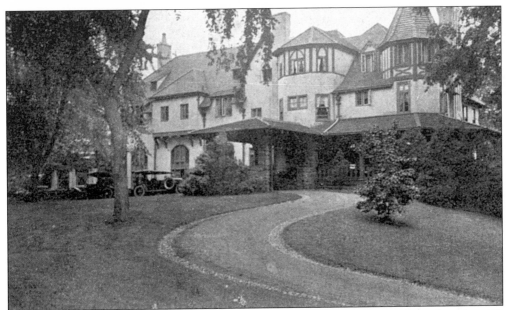

Redstone later became an inn. Russell had suffered a financial reversal and was forced to sell Redstone and change his high style of living. He wrote a book, *The Romance and Tragedy of a Widely Known Business Man of New York*, which tells of his life in Short Hills and laments the dearth of friends after he lost his wealth.

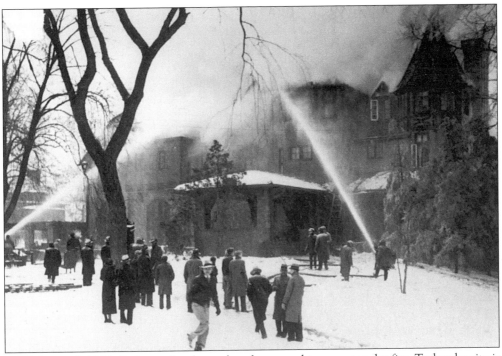

On February 5, 1934, Redstone Inn burned to the ground in a spectacular fire. Today the site is occupied by a number of houses built after the property was subdivided.

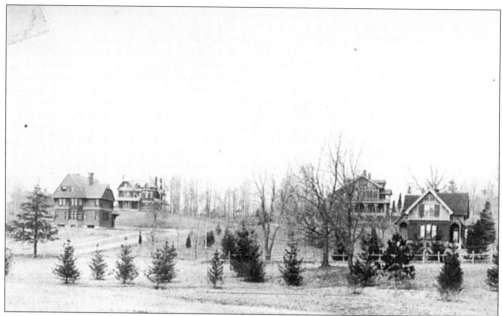

This view is from Hobart Avenue looking up Highland Avenue about 1881. From left to right are: 21 Highland Avenue in the Queen Anne (Shaw) style, 37 Highland Avenue, 32 Highland Avenue which has been extensively remodeled and is now a Dutch Colonial, and 137 Hobart Avenue (a.k.a. Hartshorn #1).

37 Highland Avenue was built in the Queen Anne (Classical) Style. This picture, extracted from a post card, shows the original house in detail. The house is now greatly altered. The third story balcony and the overhanging roof have been removed along with the right-hand porch. The front porch has been enclosed with arched windows and an iron railing added to the flat roof.

The house at 137 Hobart Avenue was the first home built by Stewart Hartshorn, other than his own, for his "ideal community." In an article written about early Short Hills the house was described as being a Swiss Chalet. Architecturally, the house is Stick Style.

This barn stood on Hobart Avenue. The well-known painter from Summit, N.J., Worthington Whittridge, captured it in this painting, with South Mountain in the background. Miss Cora Hartshorn owned the painting and willed it to the Newark Museum.

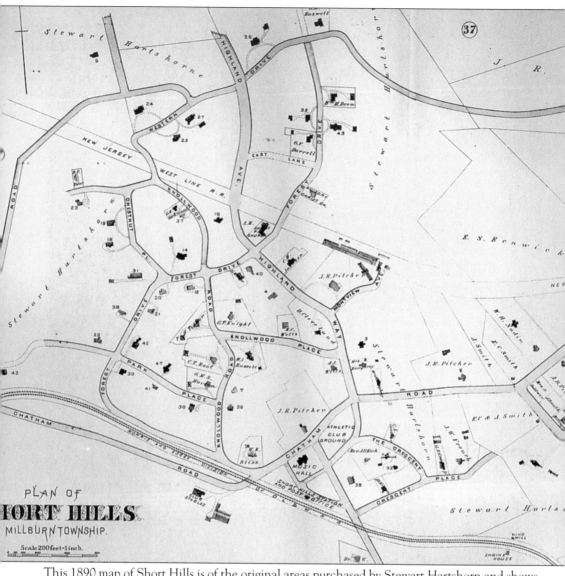

PLAN OF

ORT HILLS.

MILLBURN TOWNSHIP.

Scale 200 feet-1 inch.

This 1890 map of Short Hills is of the original areas purchased by Stewart Hartshorn and shows his design of curving streets that follow the contour of the land. He ultimately purchased 1,552 acres extending to Great Hills and White Oak Ridge Roads and into part of what is now the Canoe Brook Country Club.

The Hartshorn estate is in the lower right. After Mr. Hartshorn's death in 1937, the mansion was dismantled and the area developed with the building of Great Oak Drive, Pinewood and Homestead Courts, and the extension of Crescent Place.

Notice the route for the New Jersey West Line Railroad, which, if it had ever been put into operation, would have crossed the village at Barberry Lane, gone behind Christ Church, and then crossed Highland Avenue and traversed what is today a major portion of Western Drive. The black rectangle on the railroad line indicates storage sheds built for the use of the construction crews. Some of the streets shown were realigned, notably Taylor Road and Jefferson Avenue.

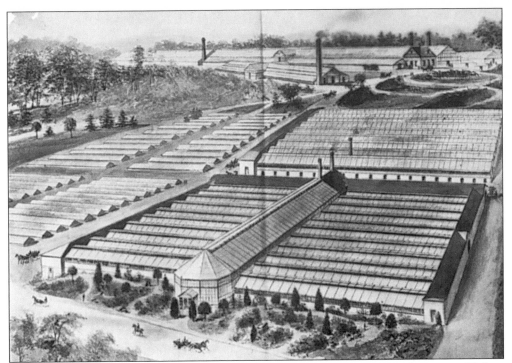

In the 1890s, Pitcher and Manda had their extensive U.S. Nursery greenhouses on Hobart Avenue covering much of the area of Gap View Road and Inverness Court. The firm was known worldwide for their exotic plants including ferns and orchids.

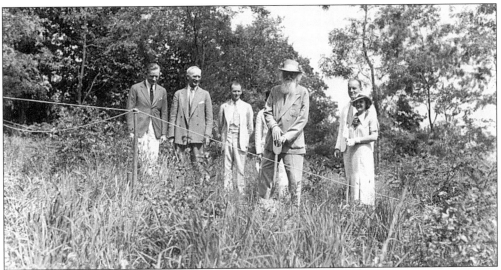

In 1935 Mr. and Mrs. Donald Simler purchased a lot at 10 Gap View Road. In July a formal groundbreaking ceremony was held with Mr. Hartshorn, Millburn Mayor Barker, the builder W. W. Drury, and Mr. Hartshorn's surveyor Ferris T. Watts in attendance. Note Mrs. Simler's white gloves. Mr. Hartshorn, now in his 95th year, requested and received permission to supervise the construction.

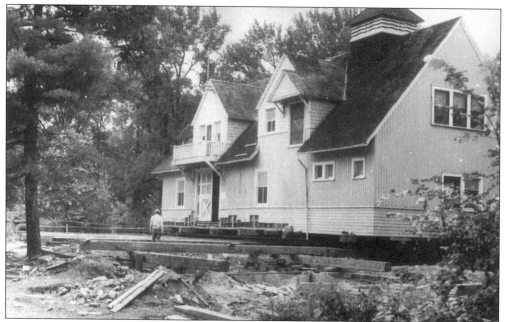

The building at 59 Montview Avenue was originally the carriage house for 40 Highland Avenue. In 1947 it was moved to the current location and converted to a private home. It was common to move buildings rather than tear them down. Today, with the utility lines, the heavy street traffic and high cost, it would be practically unthinkable.

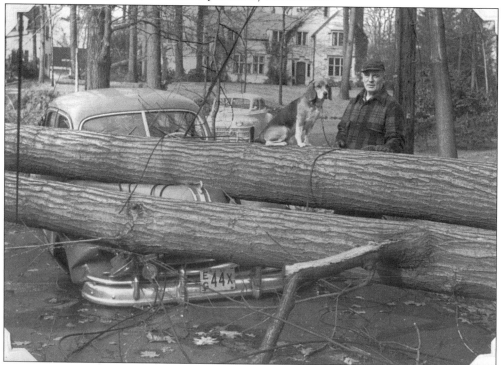

On Nov 24, 1950, a hurricane came through town and did extensive damage. A neighbor surveys a crushed car on Delwick Lane at Montview Avenue.

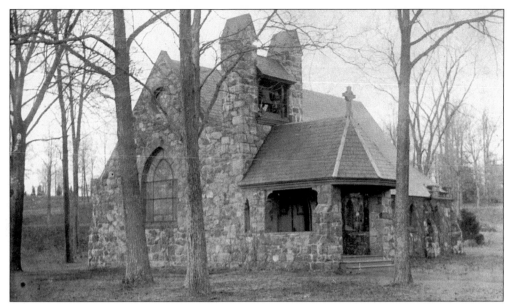

The Christ Church (Episcopal) congregation was organized in 1882. Construction of the church building was begun in 1883 on land donated by Stewart Hartshorn at the corner of Highland Avenue and Forest Drive. This picture is of the original western facade.

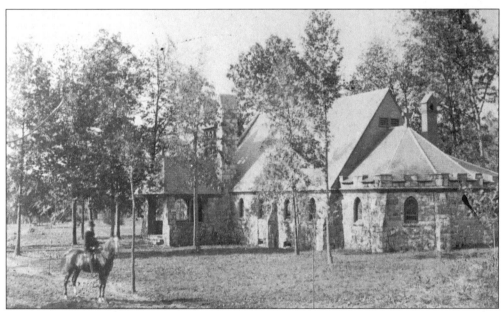

This picture is of the south and east facades of Christ Church. Based on the size of the trees along Forest Drive, it probably dates from around 1886. The building was designed by Charles A. Rich of the noted firm of Lamb & Rich. His family resided at 12 The Crescent, which the firm also designed.

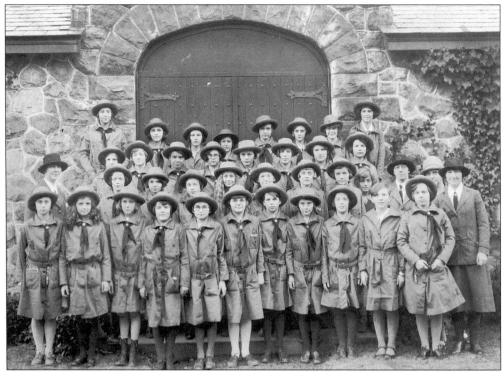

The first Girl Scout troop in town was organized in 1927. The troop of 35 girls posed with their leaders in this 1928 or 1929 photograph in front of the Guild Hall at Christ Church.

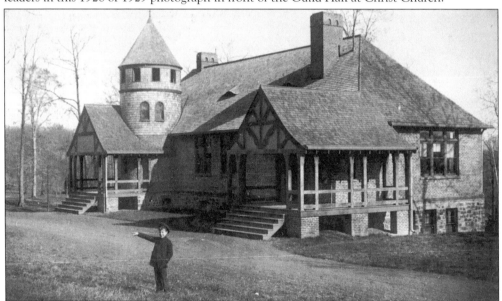

Stewart Hartshorn, in July 1891, began construction of this building on East Lane for his community school. On April 2, 1898, the school was incorporated as the Short Hills Country Day School. Over the years a gym, a lunchroom, and two additional buildings were built. In 1962 the buildings were sold to Christ Church and the school moved to a new campus at White Oak Ridge and Parsonage Hill Roads.

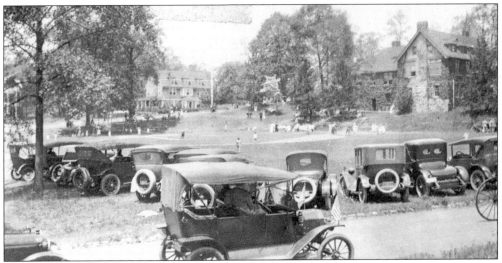

This was the playing field for the Short Hills Country Day School. Quite an entourage of fans was present with their variety of automobiles to watch this baseball game in May 1917. The field, now owned by Christ Church, is still open to use by the community.

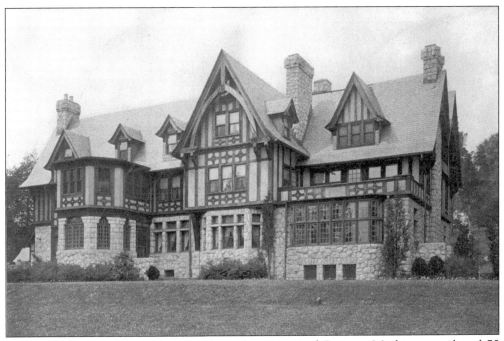

Thomas J. Watson, founder and president of International Business Machines, purchased 75 Western Drive, "Berryfield," in 1917. At that time the address was Taylor Road, which included portions of Western Drive and Stewart Road. Mr. Watson was active in church and community affairs and owned the property until 1936. The house is little changed today.

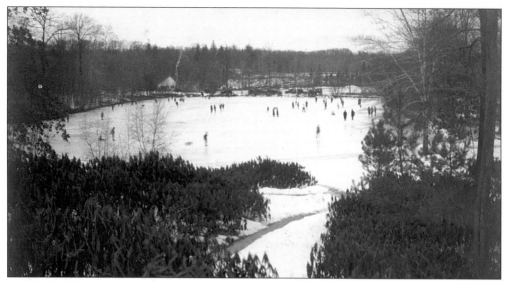

Ice skating was a popular winter pastime. These skaters are on South Pond. Lake Road is in the distance and the Short Hills Club is out of the picture to the left. Club members used the pond for swimming during the summer.

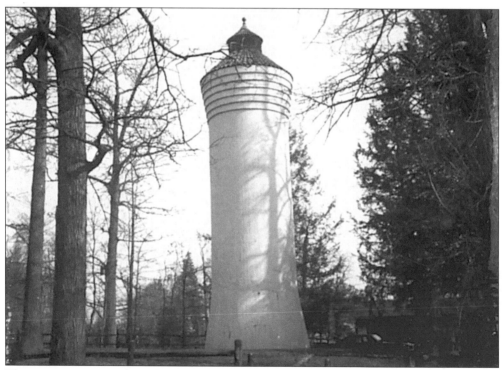

This stucco tower stands on the southeast corner of Hartshorn Drive and Parsonage Hill Road. It was constructed by the City of East Orange to provide additional pressure for moving the water from the reserve on Parsonage Hill Road through the pipes to East Orange. The house at 225 Hartshorn Drive was designed to architecturally blend with the tower.

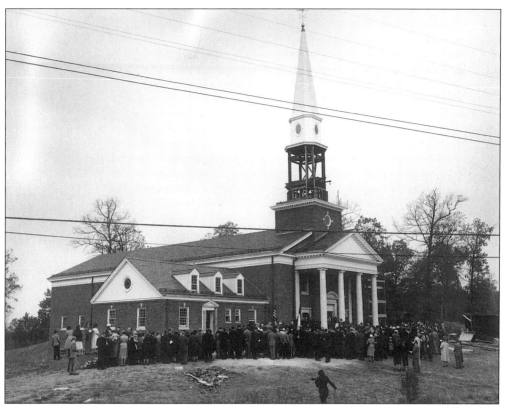

Built on part of a wood lot given in 1746 to the minister of the Springfield Presbyterian Church, the Community Congregational Church was founded in early 1953. Early worship services were held in the Racquets Club and the Short Hills School on Hobart Avenue. This photo documents the laying of the cornerstone on October 21, 1956.

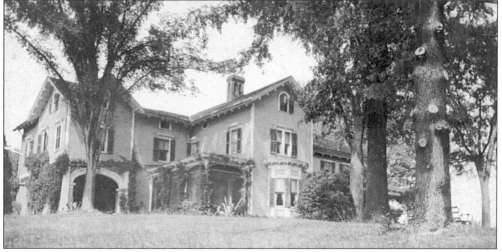

A noted summer resident of Short Hills was Mayor A. Oakey Hall of New York City, a member of the infamous Tammany Hall. He had a home built on the north side of Parsonage Hill Road near Hartshorn Drive. It is no longer standing. Reputedly, the home was built with New York City laborers and funds. We owe the names of Oakey Drive and the Oakey Tract to this family.

117

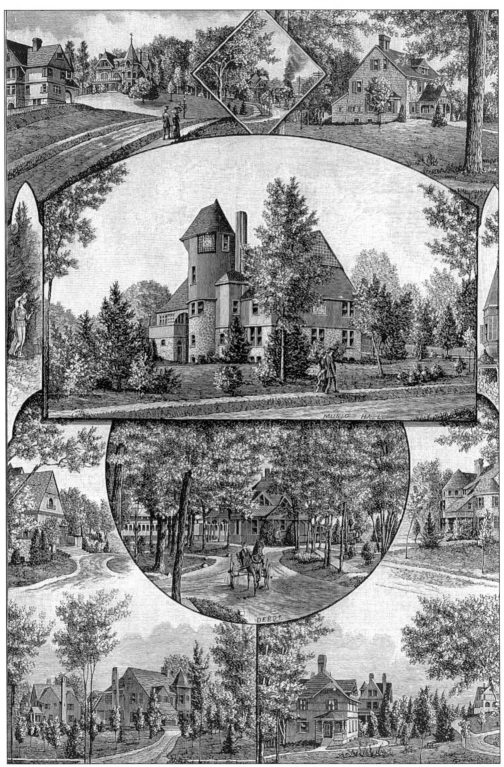

This etching depicting scenes of Short Hills is from the "Leslie Illustrated" and is dated 1880.

118

Eight

MORRIS TURNPIKE, WHITE OAK RIDGE, AND DEERFIELD

The Millburn Recreation Bowling Academy provided a popular pastime for Millburn residents in the 1930s and 1940s. The building is at 610 Morris Turnpike and has been altered several times.

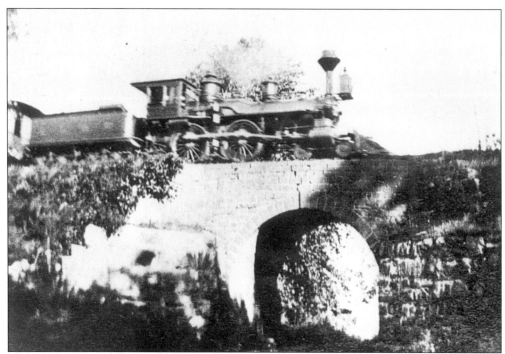

The arch railroad bridge on Morris Turnpike had to undergo major rebuilding in the 1890s when a large crack appeared at the top. The steam engine, possibly the "Old Sussex," was most likely manufactured about 1882. This type of engine was in use on the main line of the Delaware, Lackawanna, & Western Railroad through 1912.

A woman on a buckboard pauses by the rebuilt arch bridge. Morris Turnpike was built as a toll road to the west shortly after 1800. At gates along the route, farmers who maintained the road collected tolls. The Shunpike, which parallels Morris Turnpike to the south, was built to avoid paying toll charges.

In 1806 The Rev. John Henry Hobart rented a farm in Short Hills so that his family could escape the city turmoil and summer heat. In 1808 he bought property, ultimately 175 acres, on what is now known as the Hobart Gap. He offered a portion of his land in Short Hills on which to build the General Theological Seminary but in 1814 it was sited in New York City.

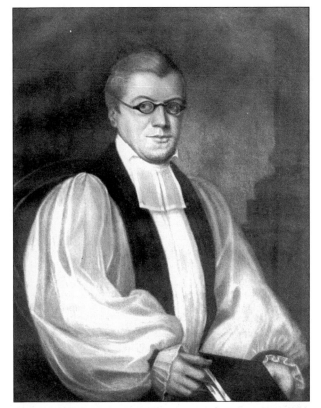

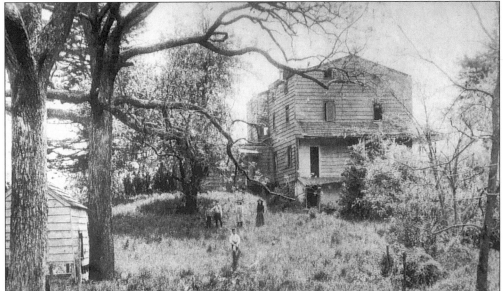

The Hobart house was located on the northeast corner of Hobart Avenue and Bishops Lane. It was said that when Bishop Hobart was needed in New York, a lantern or flag would be hauled to the top of the steeple on Trinity Church. Sighting the signal through his telescope, he would start on the day-long trip to the city. The house fell into decay and was torn down after the death of his son in 1868.

Brantwood was developed about 1900. This 1917 scene looks down Hobart Avenue toward South Terrace. Several noted architects designed homes in the area including: George B. Post, 303 Hobart Avenue ("Twin Oaks"); Wilson Eyre (co-founder and editor of *House & Gardens*), 314 Hobart Avenue; and illustrator Will Bradley, 236 and 370 Hobart Avenue.

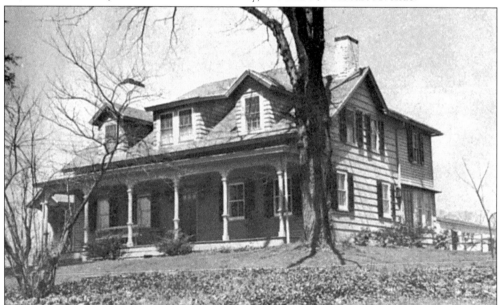

"Spruce Knoll," once the farm of the Wood family, is on Morris Turnpike, behind a white rail fence. It was constructed circa 1730 and is one of the few examples of a pre-Revolutionary farmhouse still existing in town. A second, similar building, which stood a short distance to the west, was owned by the Brant family. It was torn down in the 1960s as derelict. These two farms are the probable source of the name Brantwood.

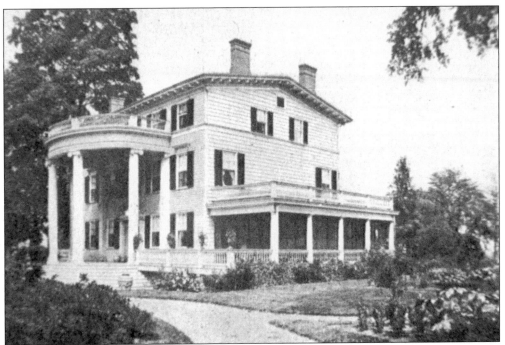

The Wallace home was built in the early 1900s. The family owned much of the land now occupied by the Mall at Short Hills and the Office Center at Short Hills, Canoe Brook Country Club and the Poet section of Short Hills. In the 1930s and 1940s the building served as an upscale restaurant called "The Brook." The building was destroyed by fire in 1947.

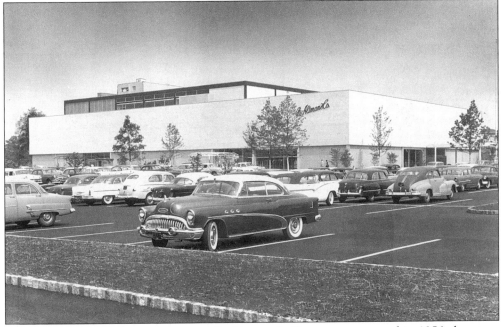

The building for the department store, B. Altman & Co., was constructed in 1956 almost on the site of the Wallace mansion. It was the first building of what ultimately became the Mall at Short Hills. Today, the department stores of Nordstrom and Neiman Marcus occupy the site.

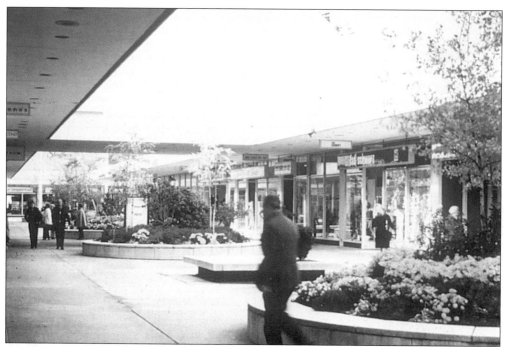

In 1961 an open air Short Hills Mall was completed by Prudential Insurance Company, several hundred feet to the rear of the B. Altman & Co. store. It was generally believed that the agreement between Prudential and Altman's contained a clause requiring any new stores to be at that distance.

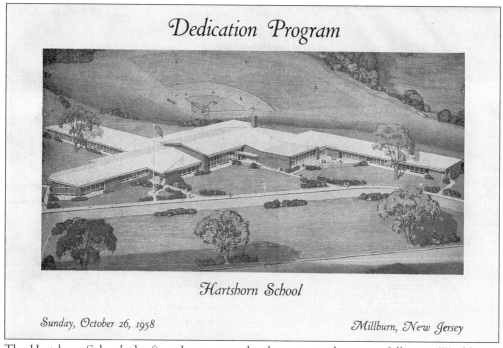

Dedication Program

Hartshorn School

Sunday, October 26, 1958 *Millburn, New Jersey*

The Hartshorn School, the first elementary school constructed in town following World War II, was opened in 1957. Extensive additions have recently been completed.

The "Short Hills Airport" was officially in operation for one day, May 18, 1968. Here, a plane has just landed on Kennedy Parkway, which was closed so that pilots could participate in a fly-in at the Short Hills Mall. The planes were lined up for viewing by the public at a parking lot near Bloomingdale's, visible in the rear. Fire, police, and first aid units were on hand to respond to any emergency.

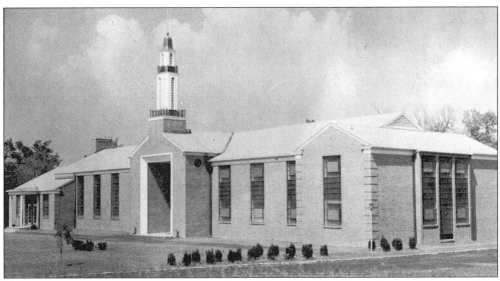

The groundbreaking ceremony for the building of the Church of Jesus Christ of the Latter-Day Saints on White Oak Ridge Road was held in October 1953. The church was dedicated on September 16, 1956, and Ezra Benson, secretary of agriculture in the cabinet of President Dwight D. Eisenhower, gave the dedicatory address.

The Parsil Cemetery and Nicholas Parsil home are located on the north side of Parsonage Hill Road at the intersection of White Oak Ridge Road. Early members of the Parsil family are buried here including Thomas, who died July 4, 1776, from wounds in a battle at Connecticut Farms, and his brother Nicholas who died June 23, 1780, in the Battle of Springfield.

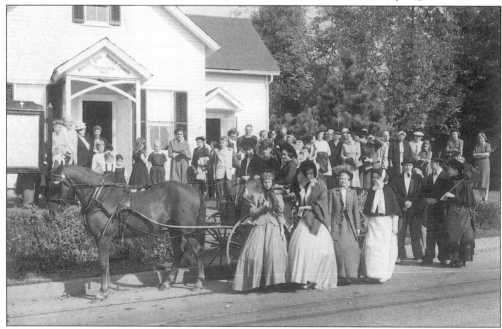

On October 14, 1956, members of the White Oak Ridge Chapel celebrated the 125th anniversary of its founding. The Chapel traces its origin to a meeting held by William Parsil in October 1831 to organize a Sunday school. Early meetings were held in homes, later in the wooden schoolhouse on White Oak Ridge Road and then, after 1871, in the new chapel.

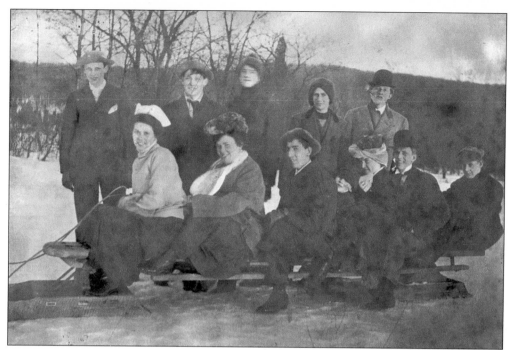

For services at the chapel you always wore your Sunday best, even in the winter. To maintain the piety of the day, recreational activities were discouraged, including sledding. Undeveloped film from 1905 was found in an old box camera in 1958; it was in good condition and this photo was printed from it. The picture shows "Ridgers" out for a sleigh ride in their Sunday best attire.

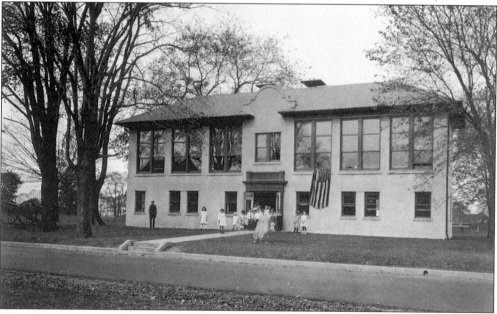

This 1920 scene shows the White Oak Ridge School building constructed in 1912. Earlier a frame schoolhouse occupied the site. Barely visible in front of the students is a boulder holding a plaque dedicated to White Oak Ridge men who fought in wars. It disappeared during the construction of White Oak Ridge Park now called Gero Park.

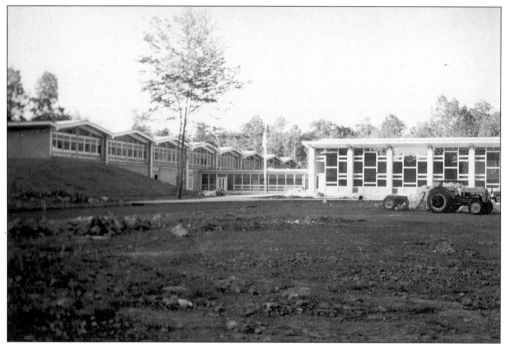

The Deerfield school was opened in 1962 to handle the burgeoning grade school population in the northwestern part of town. Unlike any other school in town, classrooms were built into the hillside. Two new wings containing 16 classrooms have recently been added.

In 1968 Congregation B'nai Jeshurun occupied their new temple on South Orange Avenue in Short Hills. Much of the land was purchased from former Congressman Robert W. Kean, whose family had owned the property since it was granted by George III of England. The aerial photograph dates from April 1976.